SALT DREAMS | JIMMY AND DENA KATZ

For Marilyn Katz

SALT DREAMS

PHOTOGRAPHS BY JIMMY AND DENA KATZ

TEXTS BY VICKI GOLDBERG AND FRANCIS DAVIS

pH powerHouse Books New York, NY

Penguins with Burning Feet, or, The Desert According to Katz

Many centuries ago, ascetics had a penchant for hiding themselves in the desert to mortify their flesh and be alone. Some of them got caught in the crowded company of their hallucinations. Some of them ended up as saints.

Saint Jerome wrote a friend: "In the remotest part of a wild and stormy desert, burnt up with the heat of the sun, so scorching it frightens even the monks who live there, I seemed to myself to be in the midst of the delights and crowds of Rome.... In this exile and prison to which through fear of Hell I had voluntarily condemned myself, with no company but scorpions and wild beasts, I many times imagined myself watching the dancing of Roman maidens as if I had been in the midst of them." Saint Anthony, on the other hand, according to painters like Bosch and Grunewald, was beset by men with pig's snouts or turtle shells, or monsters with leprous flesh.

In America today ascetics are pretty scarce, the desert is half tamed, and desert hallucinations are solid, freely available, and largely factory issue. Jimmy and Dena Katz trained a large-format camera on the drunken reality of the salt flats of northern Utah, where incongruous object shakes hands with natural circumstance. Oh, sometimes the photographers recorded an almost uninterrupted desert too, but their best pictures matter-of-factly present meetings that would be at home in cartoons or daffy dreams. To wit: someone has lugged two couches out across the parched ground into the dubious shade of a bush, presumably to watch a race or a launch: the spectator culture will not be denied, nor will it do without its comforts.

A memorial to a dead cowboy, with metal silhouettes of riders, is planted where no deer and no buffalo roam (no cows either, for that matter), but a full bottle of whiskey has been propped up beside it in case the afterlife has room for binges.

For most of photography's history, humor was considered a minor subject at best, but people like Robert Doisneau and Elliott Erwitt taught us that it was a worthy field for photography to play in. It would be possible, if one were so inclined, to read the Katzes' pictures as a commentary on what invading citizens have done to a landscape, but it seems to me more like what the landscape lured them into, provoking a lust for speed and space and conquest and a kind of lunatic domestication that suits the place about the way an apron would suit the Venus de Milo.

Richard Misrach photographed the same territory some years ago in a compelling and beautiful series of images rife with the anger and rue of a committed social documentarian. Misrach's desert is tinged with regret and bristles with violence: radiation poisoning, gun practice with *Playboy* as the target, military weapon testing. Jimmy and Dena Katz's desert is full of crooked smiles. They aren't reformers or investigative reporters, but more like street photographers in the pathless desert looking for incidents that belie expectation. Their pictures confirm the outline of an American eccentricity that expresses itself more often in outdoor décor, like dinosaurs and Michelin men on the roadside and light-up elves on the lawn, than it does in personal habits. The desert in this book is as distinctly American as Forest Lawn or Las Vegas.

And though the Katzes' desert can be pale and bleak as sand, as in a photograph of a tan man in a brown canvas chair in a vast, pale beige landscape under a paler beige sky, even their colors—and the centrality, perfect clarity, and the kind of loving fetishization of people and objects that photographs do so well—usually have the cheery contrasts of advertisements, with bright blue skies, red shirts and caps and cars, blue trousers and mountains to go with the skies. There's a boy in a brilliant red Superman cape standing by the shiny green nose cone of a rocket that grew a bit faster than he, and the back of a motorcyclist who's constructed of hard red and black shapes and resembles a child's toy photographed against a blue and white background.

The evidence here is one more sign of how the American desert, and perceptions of it, has changed. In the first half of the nineteenth century, Anglo-Americans were universally frightened of it, with good reason. Some died in it and turned to bone under the sun; the Donner party was so slowed down by it that they reached the mountains too late to cross and died there instead. In the 1870s, the geological survey photographers, including Timothy O'Sullivan, W. H. Jackson, and A. J. Russell, portrayed it as America's unique destiny and a source of mineral wealth. Photographers in the first half of the twentieth century, notably Ansel Adams, Edward Weston, and Laura Gilpin, sang a desert romance—home to a vanishing race of Indians, rich with formal possibilities—but in the Depression and afterward, a temporary home for the displaced. By the 1970s, as the environmental movement gathered strength, photographers like Robert Adams and Lewis Baltz turned their attention to the ticky-tacky suburbs and phone wires that were steadily unraveling the desert's texture. Quietly, and with deceptive dispassion, they criticized the exploitation of what had once been thought intractable land but had succumbed to the notion that nature was there to be overcome.

In the Katzes' photographs, these arid reaches look more like a playground for rocketeers and speedsters—the surface of the salt flats is so fast that world records for ground-vehicle speed are regularly set there—and a theme park for idiosyncrasy. The desert has become an open and amusing invitation to incongruity. A plaster cow lies on its side, still tethered to a scrawny tree, regarding us steadily for signs of disbelief. Plastic penguins, whose feet no doubt are burning, scan the skies for signs of snow. Vehicles of many varieties—plane, car, motorbike, bicycle—gather around a beer umbrella and a panting dog in what looks like the director's corner of a stage set for an underfinanced movie. This is an American West more akin to *Blazing Saddles* than to *Zabriskie Point*.

Jerome and Anthony would scarcely have stood a chance at sainthood here. Had they blundered by some cosmic mistake into the Katzes' West, they might have ended up doing turns on a late-night comedy show instead.

—Vicki Goldberg

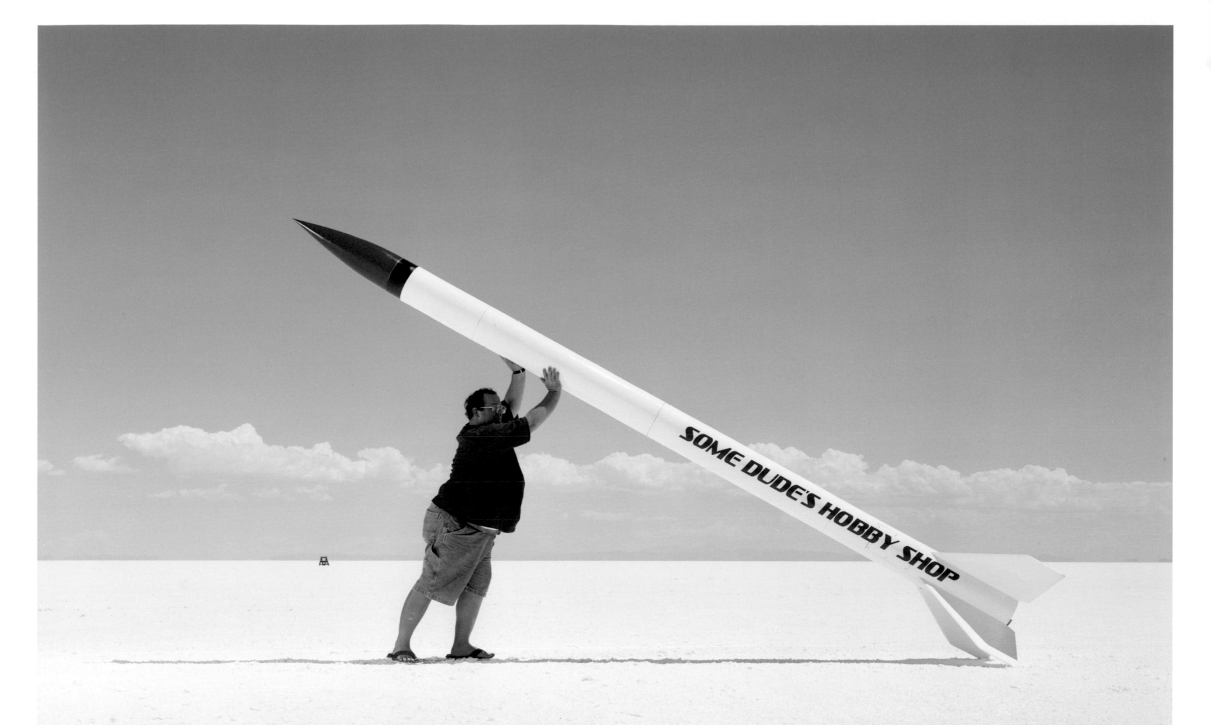

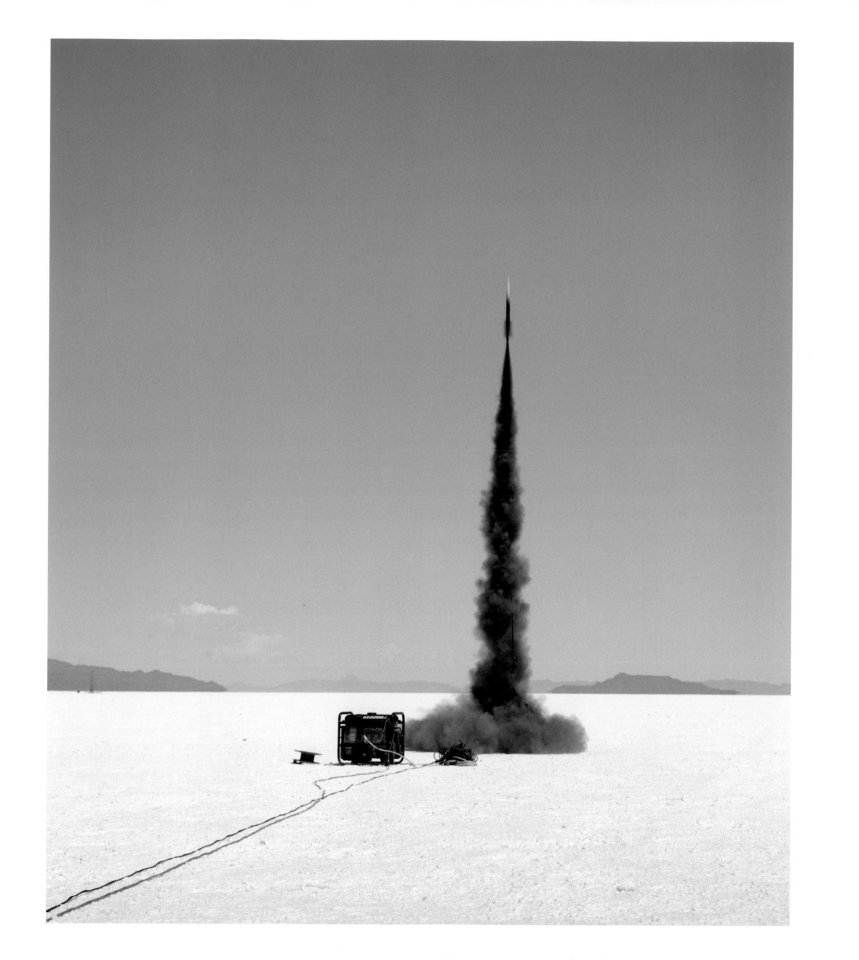

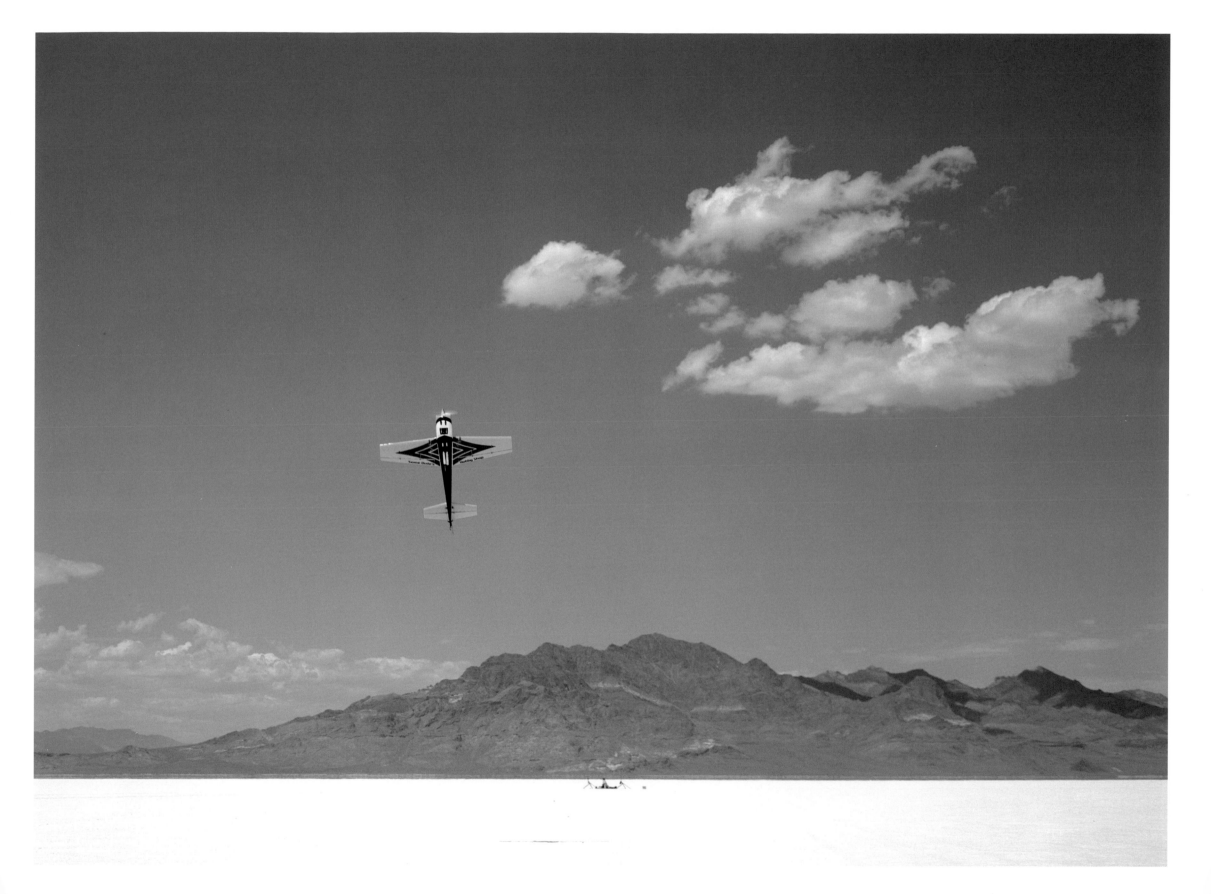

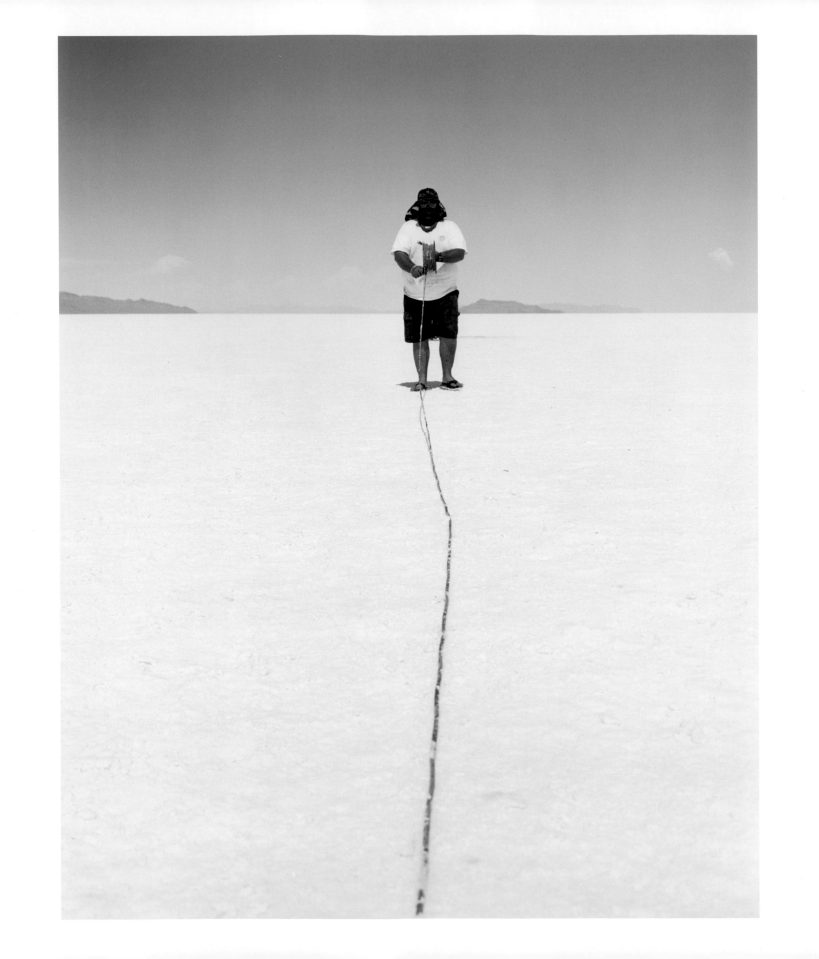

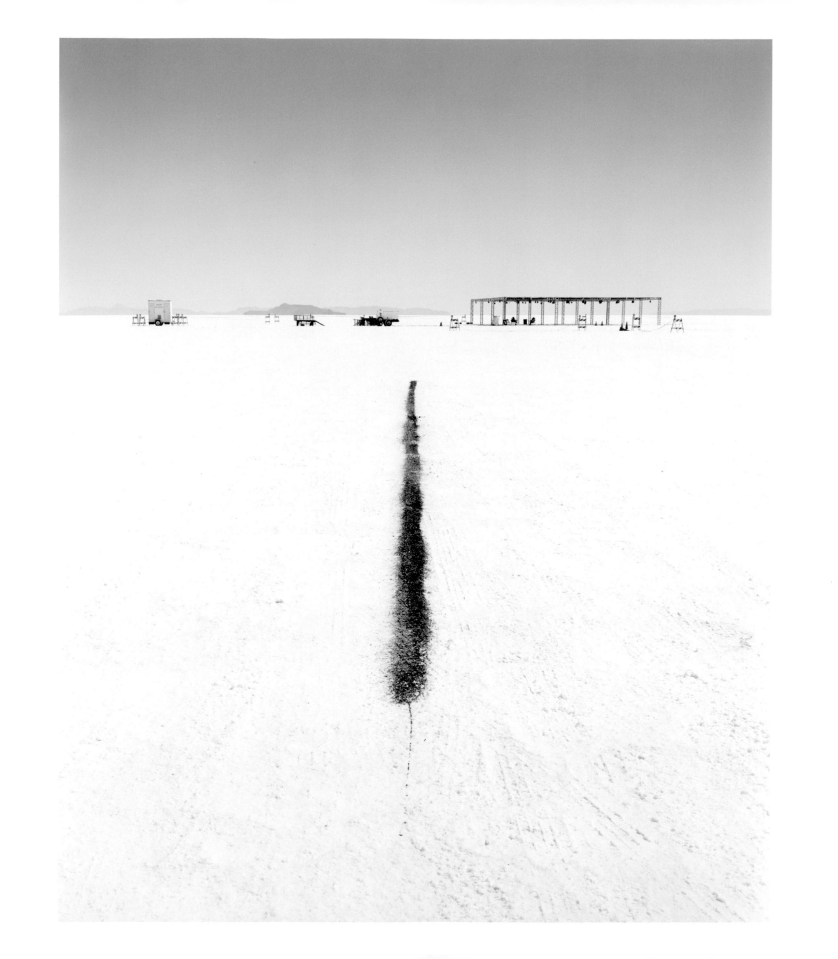

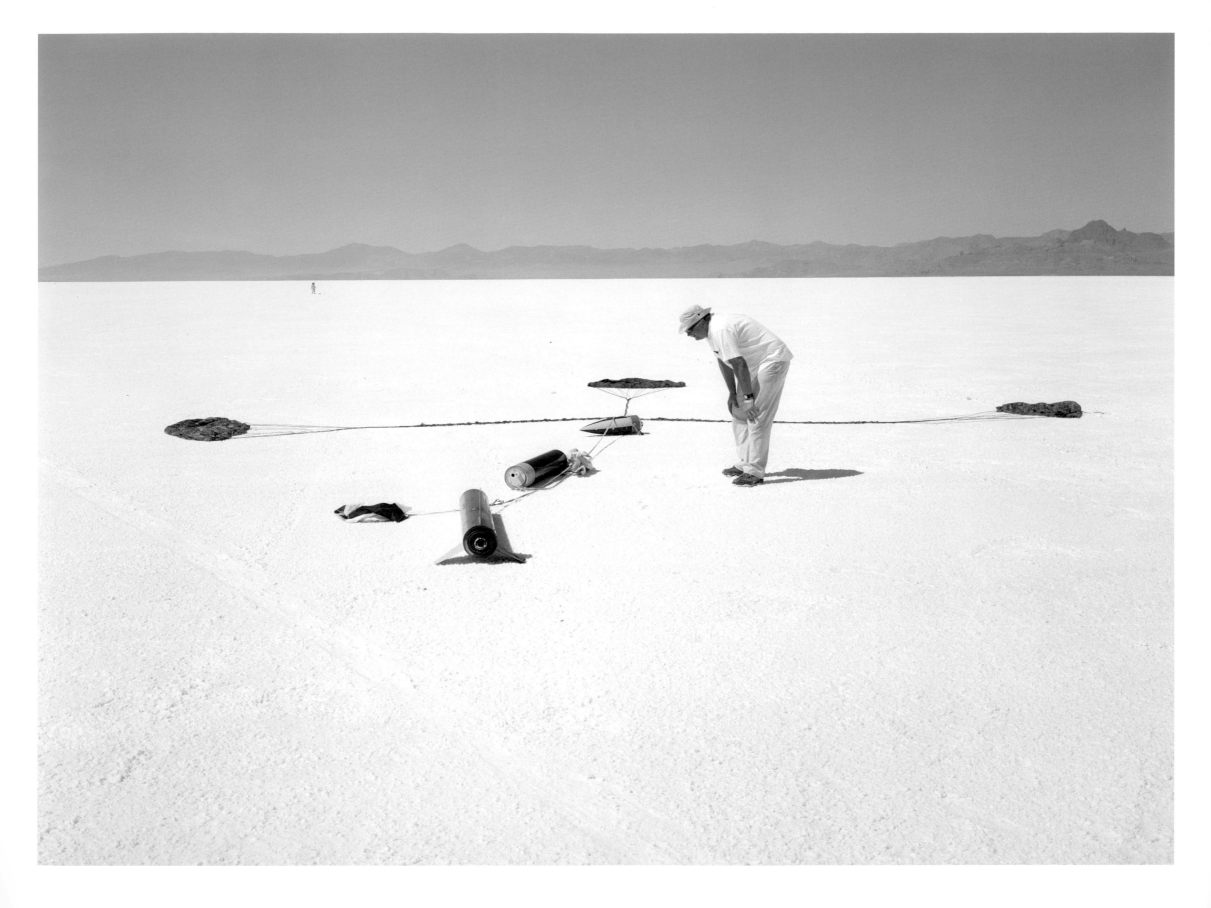

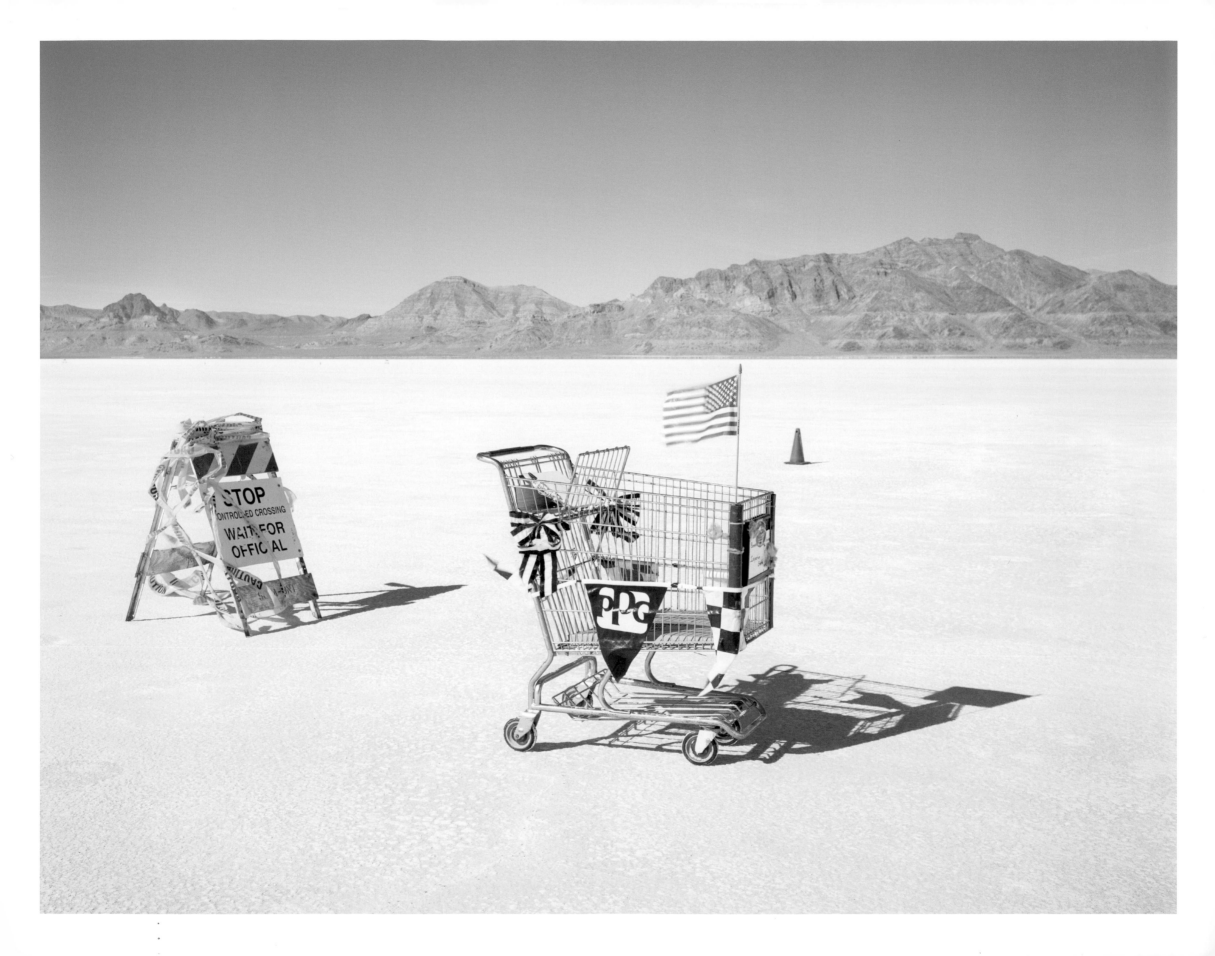

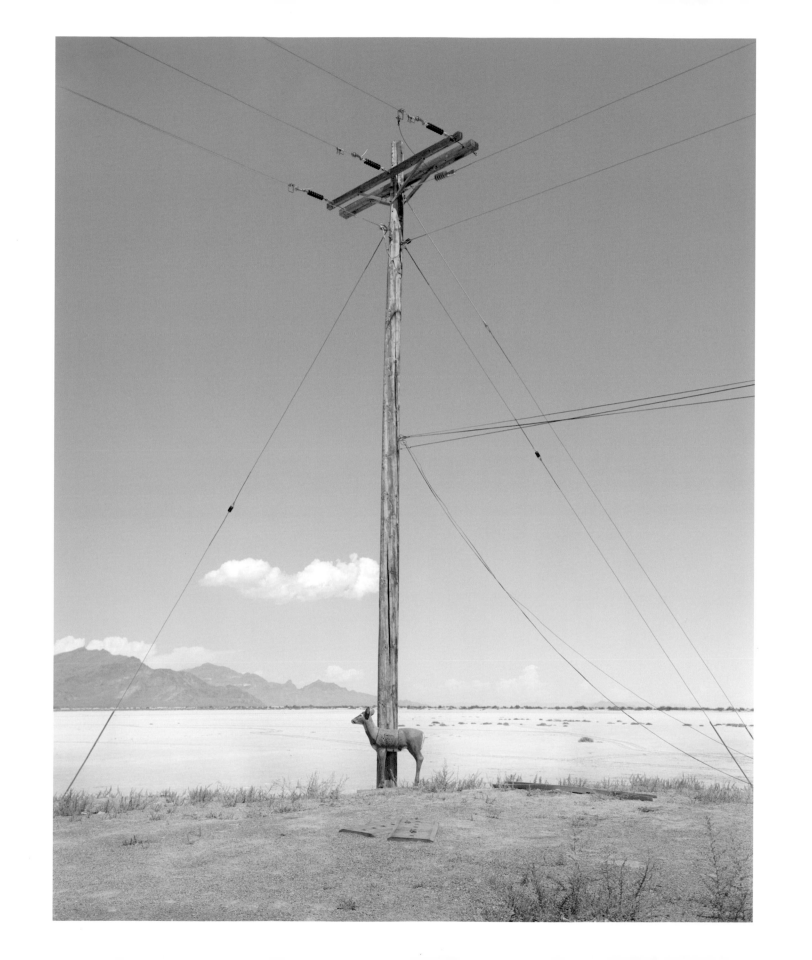

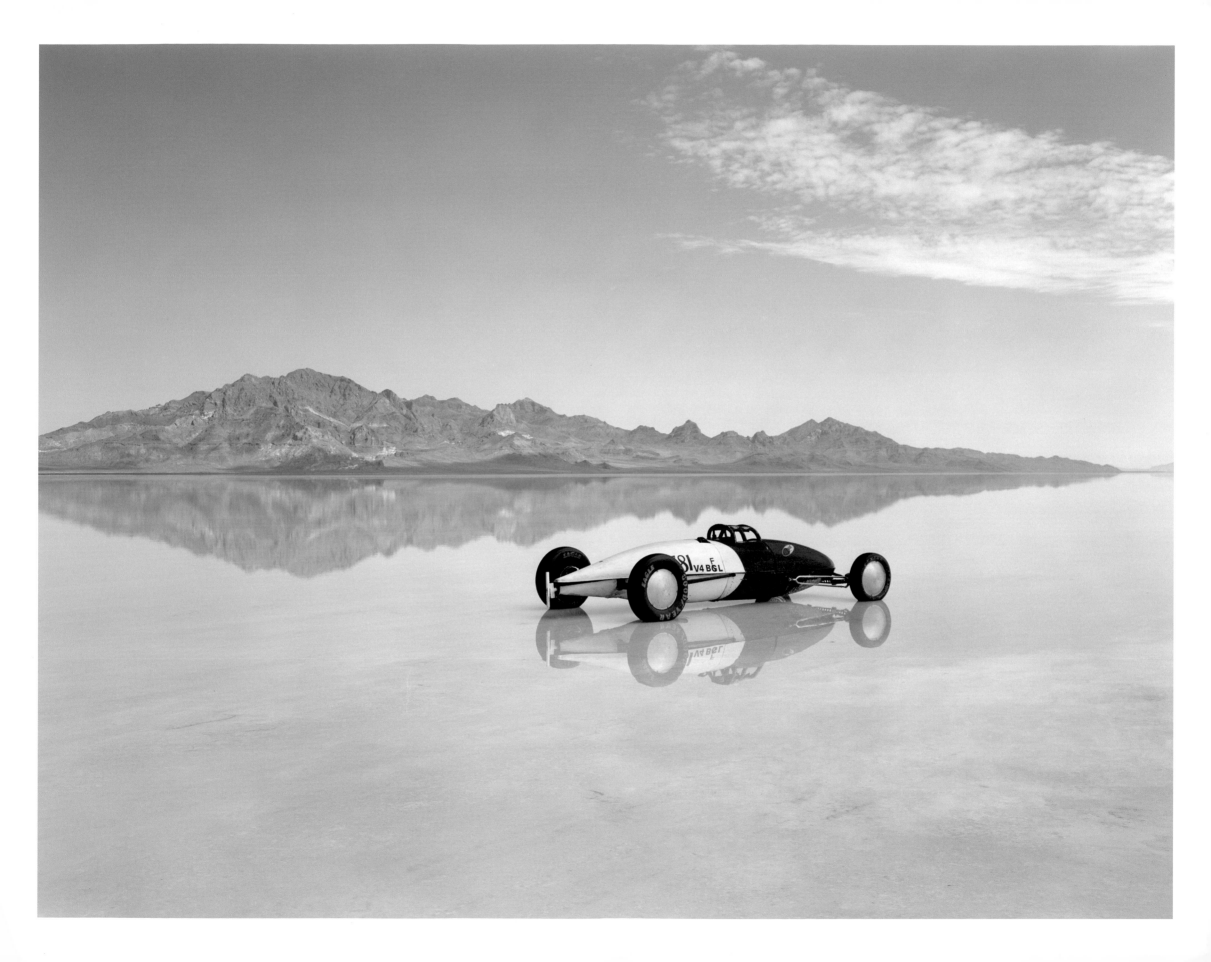

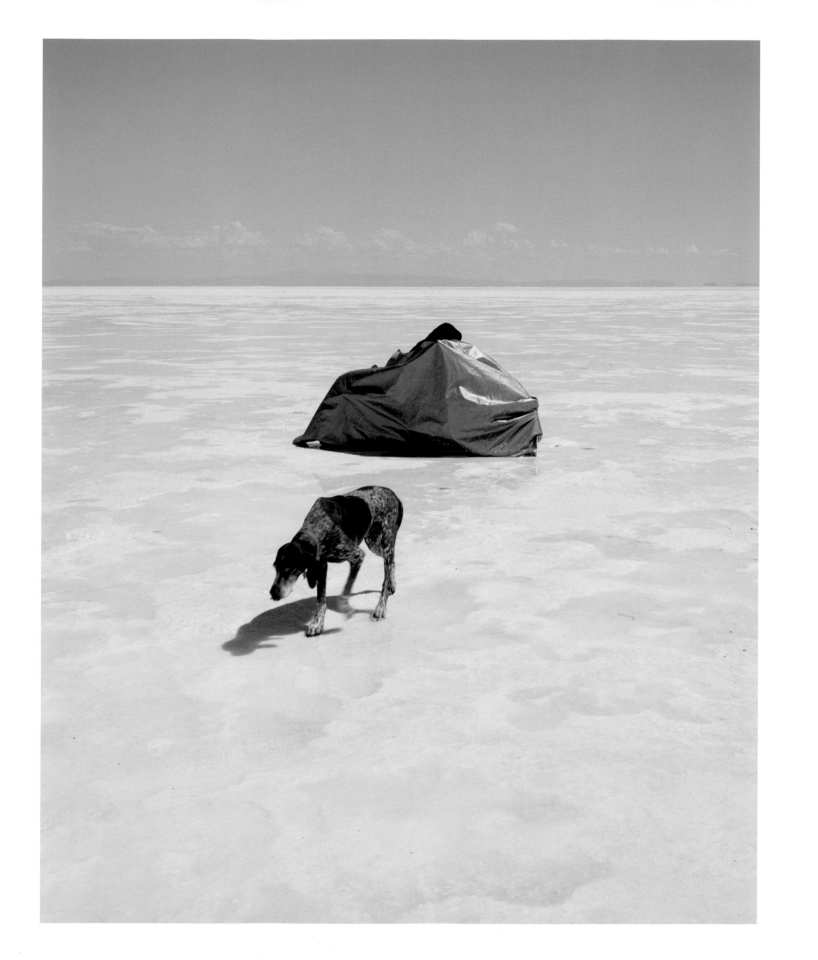

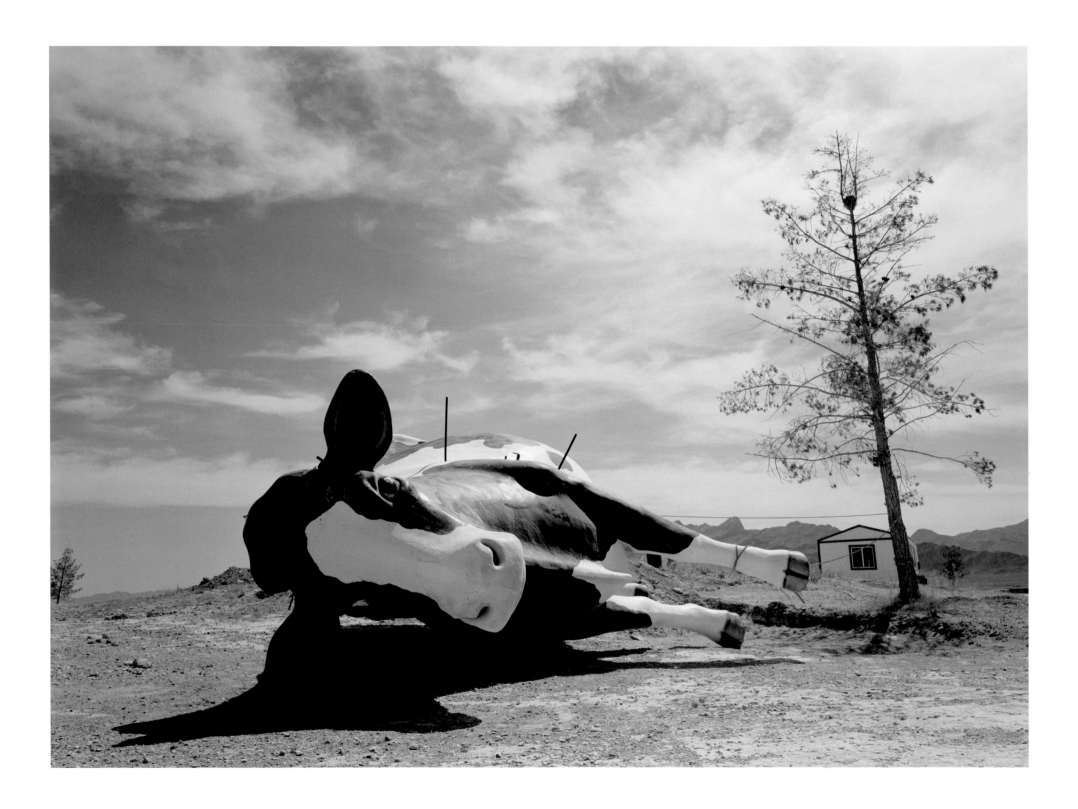

Dreams So Real:
Jimmy and Dena Katz's True West

The first image to catch my eye and capture my imagination with its sheer absurdity—the one that made me laugh out loud—was the cow with spikes in it. For a split second, you wonder if the photographers stumbled on a modern enactment of an ancient pagan ritual. But this is contemporary Nevada, not Cecil B. DeMille. The size of the cow in relation to the farmhouse and the tree and the distant mountains confirms it's a larger-than-life—if extremely lifelike—replica, possibly made of fiberglass and metal. It hasn't been toppled, much less sacrificed; it's waiting to be erected, and the spikes are probably foundation rods that will eventually be removed. Even so, what on earth is this cow doing there? Jimmy and Dena Katz don't tell us, and therein lies their art. Their images never reduce us to just looking. These photographs from the area around the Great Salt Lake are filled with naturalistic and incidental detail—yet because the detail is intensified and made peculiar by virtue of being isolated from anything that might rationally explain it, you come away from these photographs feeling there's more going on in them than meets the eye, and (the real test of photography) more going on in life than usually meets the eye as well.

Perhaps the most other-worldly and seductive of these images is *Island*, in which the Katzes show us...what, exactly? Three hazy figures materializing as if from the sky, their full shapes apparent only as reflections in the water. It's easy enough to supply a prosaic explanation for what's going on here. A man and his two children are standing on a strip of rock in the Great Salt Lake. All we actually see are a trio of amorphous creatures who appear to be striding toward us, and the backdrop they're emerging from could be paradisiacal or post-apocalyptic. Are the shapes in the water what these figures are evolving into or a vestige of what they used to be? Is this a new species or a dying one, and how is it going to reproduce itself without a woman? There is an impressive visual technique on display here, and you marvel at the physicality this and other shots in *Salt Dreams* must have required. But what's most breathtaking about *Island* is the subtlety with which the Katzes address ecological issues and the transience of human life.

Paradoxically, it's because the Katzes' images are so hyper-real that they become so dreamlike and surreal in their larger associations. The couple traveled together to northern Utah because Jimmy (one of the most stylish and prolific jazz photographers since the glory days of Herman Leonard, William Claxton, and William Gottlieb) was based there in the 1980s, when he was a professional alpinist and skier. Uninterested in taking calendar shots of glorious sunsets and perpendicular sky, they found themselves drawn to things of a sort we don't usually see in landscape photography—"man's things," as Jimmy Katz puts it. Some of this was clearly debris, like the three plastic flamingos in the water that you see on the cover. But much of it represented somebody's attempt to humanize a vast, indifferent natural expanse—oddities like the gigantic cow or, better still, the cross for K.C. HUFFAKER with cowboys on broncos lovingly welded to its horizontal beams and a bottle of whiskey by its foot (presumably erected as a memorial for a dead motorist near the spot where he fell asleep and veered off the treacherously straight road). All the same, there was no way of avoiding the area's scenic wonder, nor would Jimmy and Dena Katz have wanted to. Without belaboring the point, the juxtaposition of eternal sky and salt with *man's things* (and, in many of the images, with man himself) gets at

something sorrowful and basic—our sense of being the discordant element in nature, perishable junk ourselves (memorials are the junk that outlive us).

Though the Great Salt Lake is only a few miles from a metropolis and visible from the Salt Lake City airport, these photographs frequently give the impression of an exotic, forbidden world. The shots taken on the Bonneville Salt Flats are initially quite disorienting; the salt looks so much like snow you're surprised to see people wearing t-shirts and shorts (summer temperatures reach as high as 110 degrees). Insofar as the United States is a jigsaw puzzle of subcultures, each with its own peculiar rituals and obsessions, the flats are no different from anyplace else. Jimmy and Dena Katz allow us a glimpse—but only a glimpse—of two of the area's local rituals: a rocket launch and speed-car trials. These car events are the antithesis of NASCAR. Competitors aren't covered head to toe in corporate logos, and the only prizes are a championship hat and a line in the record book. Still, like any sporting event, these races draw crowds. A photojournalist would have given us pageantry, with shot after shot of the drivers and car-builders tuning up their engines and onlookers milling around and drinking beer. Jimmy and Dena Katz give us something better than pageantry—a point of view that allows them to become our surrogates. Like the shots of men shouldering rockets good for only a single launch, these images of men standing beside the cars with which they hope to set records hardly anyone outside their immediate circle will ever know about come across as an affectionate study of noble futility.

The world we see in *Salt Dreams* isn't Ansel Adams' or Avedon's mythic West—it's the contemporary American West as it actually is, familiar yet somehow strange to outside eyes. I'm reminded of F. O. Matthiessen's analysis of *Moby Dick*, in which he attempted to do justice to Melville's accumulation of detail with "a slow moving-picture of the whole." Melville gave us his own slow moving-picture of the whole, and so do the Katzes: each of the images in *Salt Dreams* is painstakingly individualized, but you gain a sense of a region's true character from looking at all of them in sequence. Matthiessen's cinematic analogy is wholly appropriate to *Salt Dreams* as well, given that film evolved out of photography and the two art forms in tandem have altered the way we view our physical surroundings and the way we play the events that unfold in them back in our minds (did anyone ever dream in black-and-white prior to their invention?). *Salt Dreams* might seem akin to documentary film, but in relying overmuch on establishing shots, montage, captioning, and off-screen narration, contemporary documentary filmmakers have strayed far from the principles of Robert Flaherty or even those of 1960s cinema verité. With photography, every-thing the photographer wants you to know has to be in the shot, whether immediately apparent or not—indeed, whether *visible* or not.

In a sense, Jimmy and Dena Katz's images finally have more in common with the Harold Lloyd of *Safety Last* or the Alfred Hitchcock of *North by Northwest*. We don't see anything as hilarious as Lloyd dangling from a clock or as sinister as Cary Grant fleeing crop dusters. What we do see, in so many of these images, is a world recognizable as ours but in which someone or something looks vaguely or jarringly out of place—a world like the one in our dreams, in which hyper-real and surreal are often different words for the same thing.

—Francis Davis

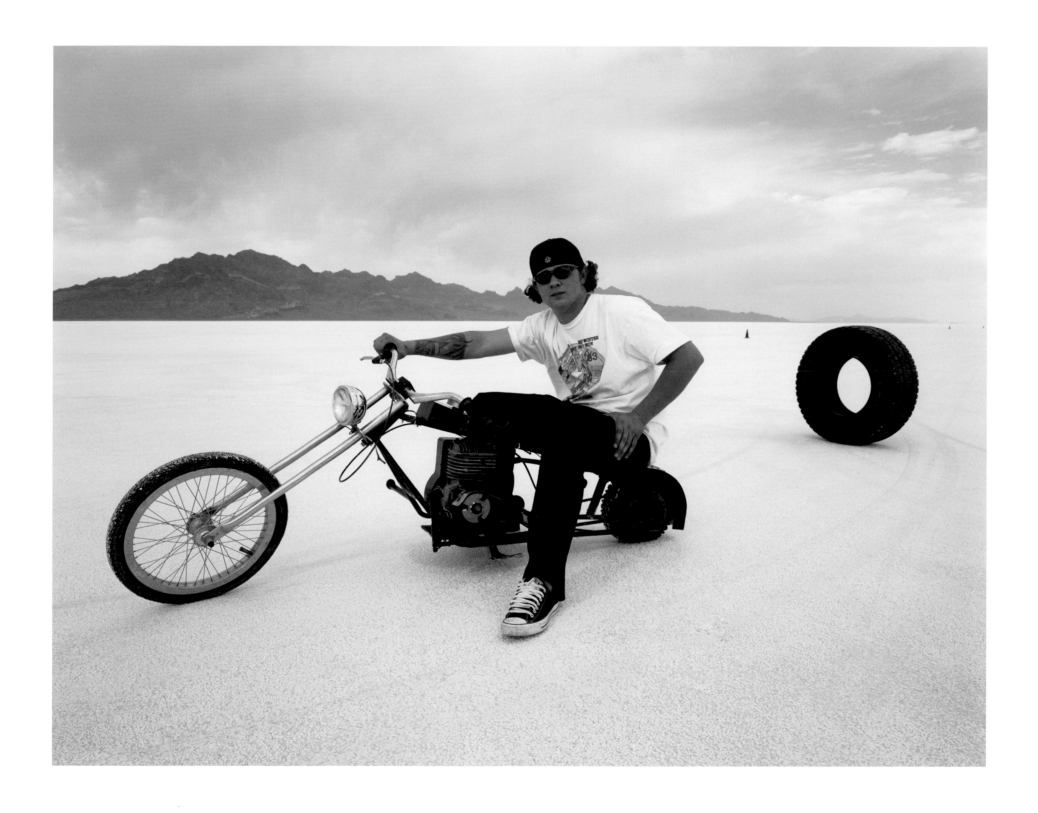

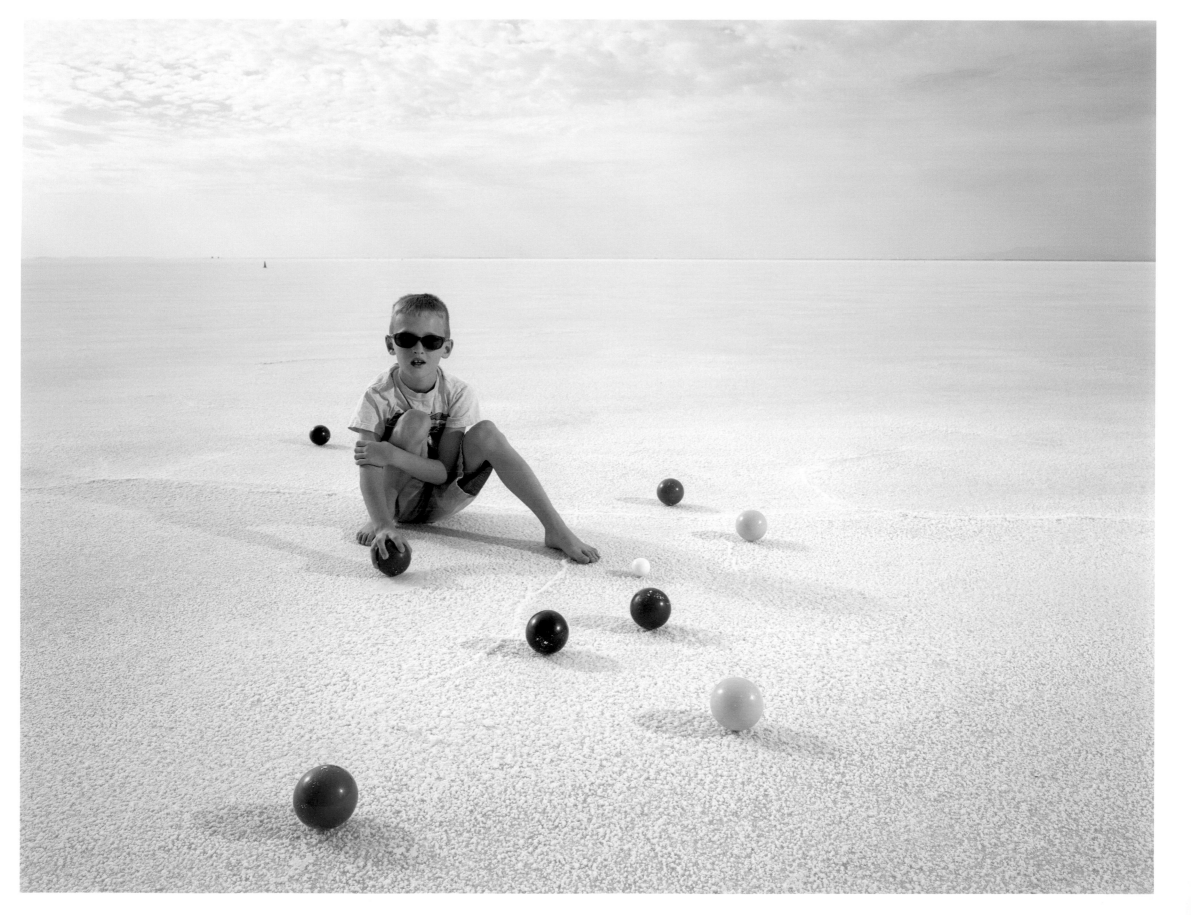

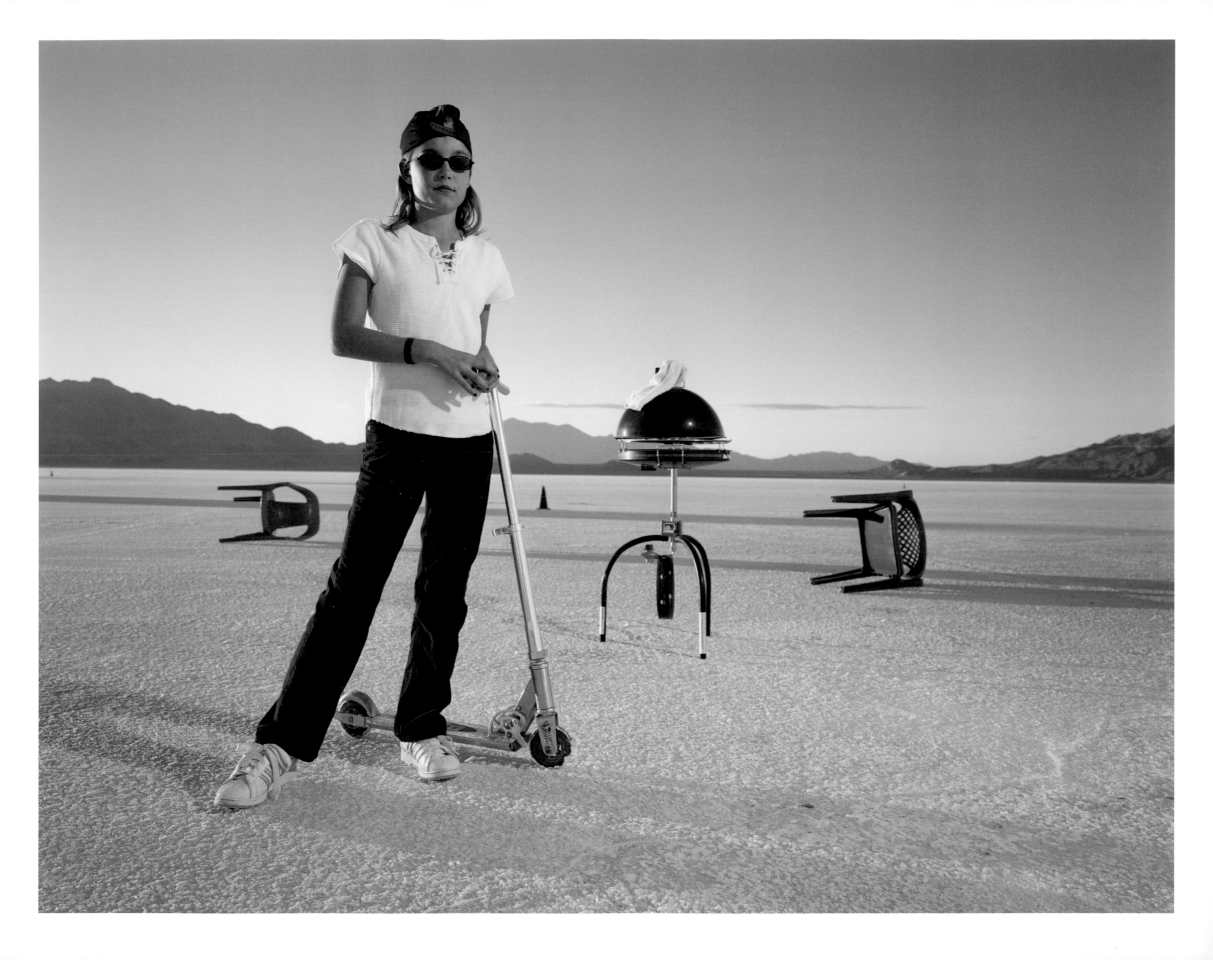

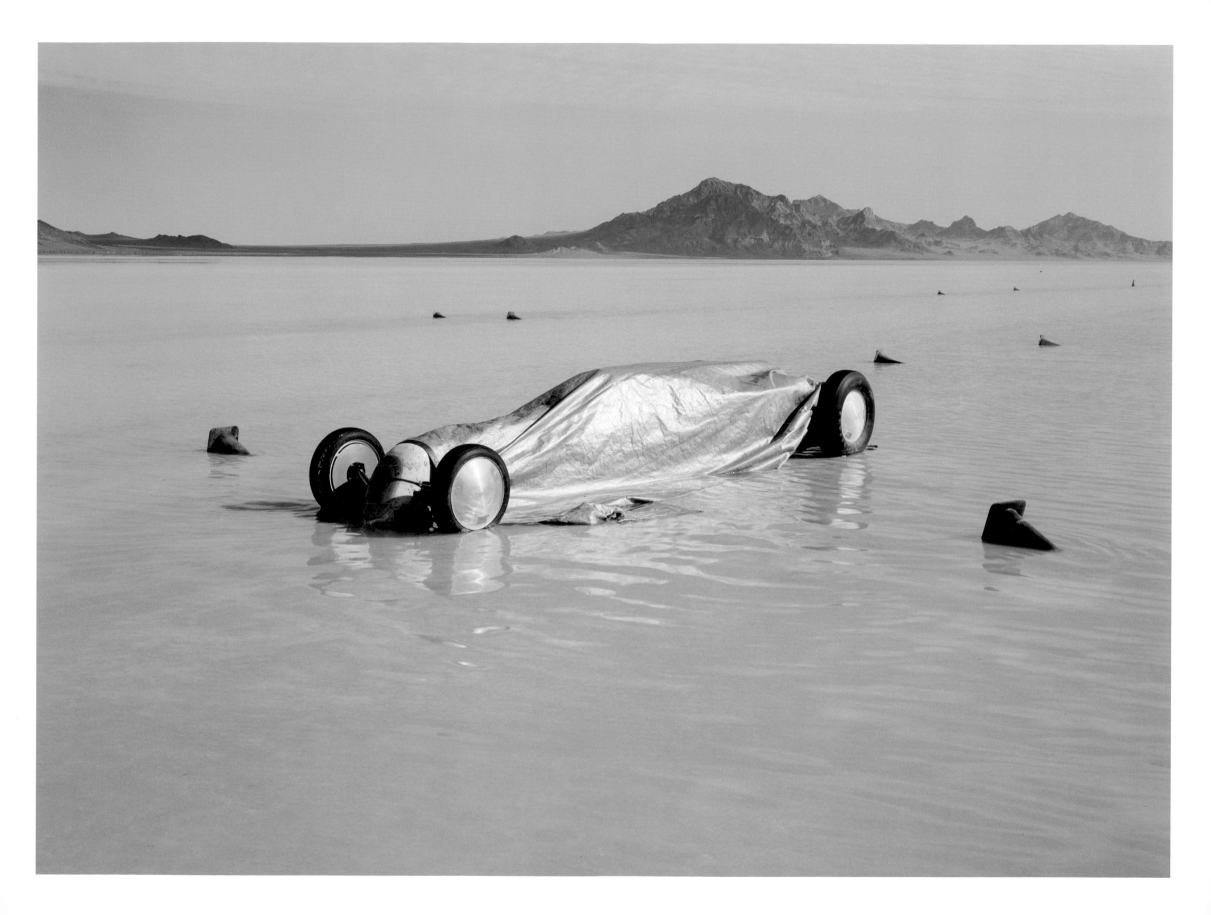

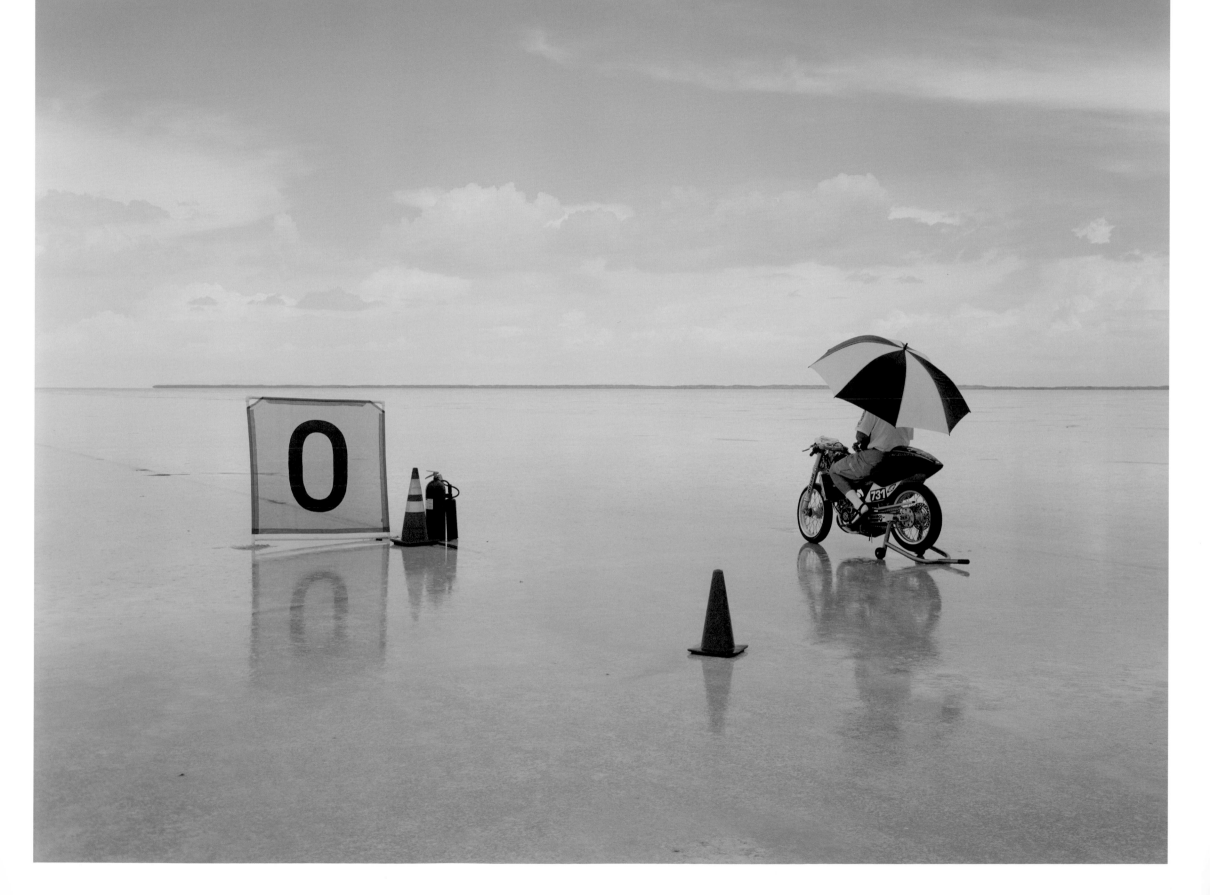

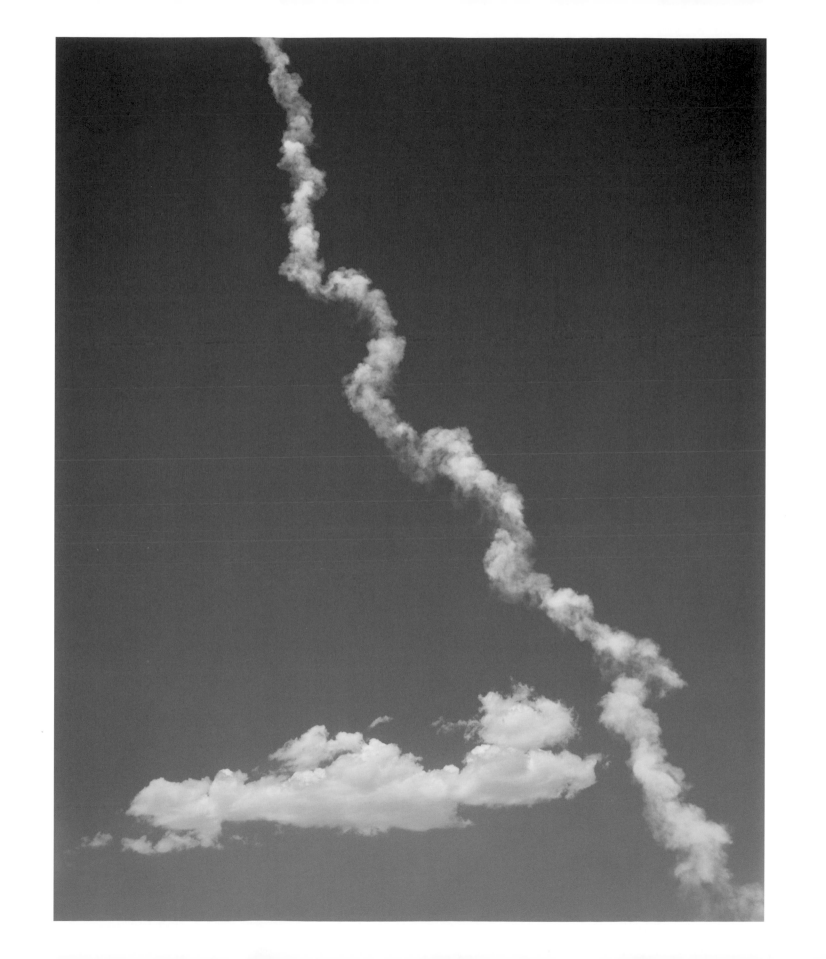

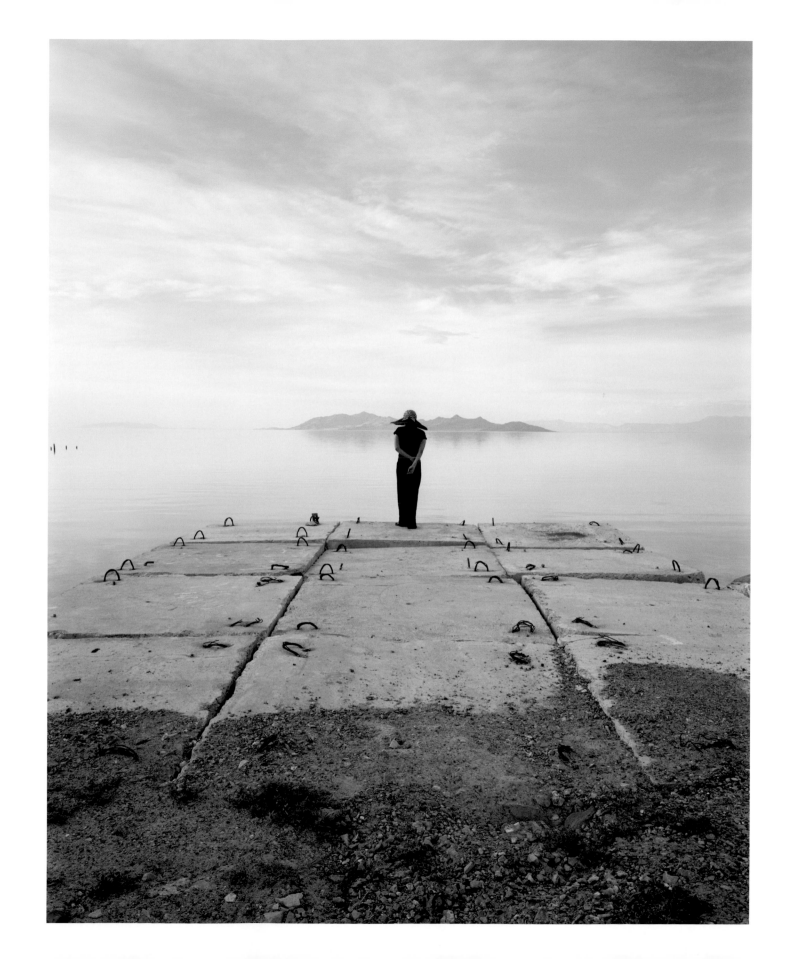

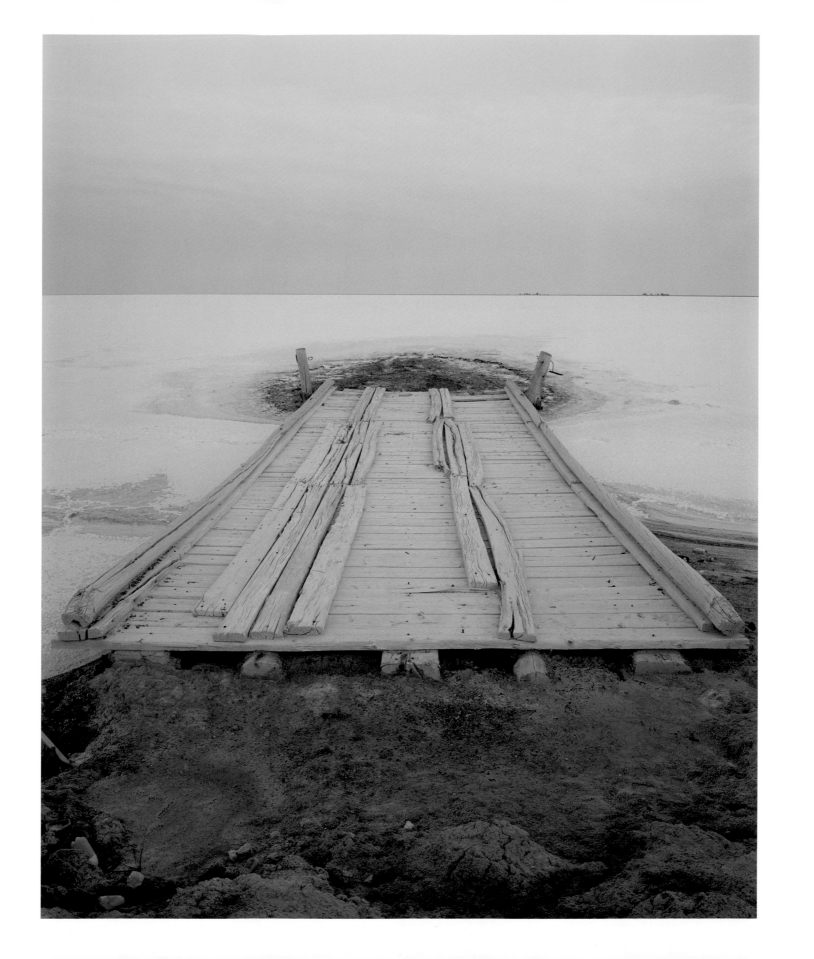

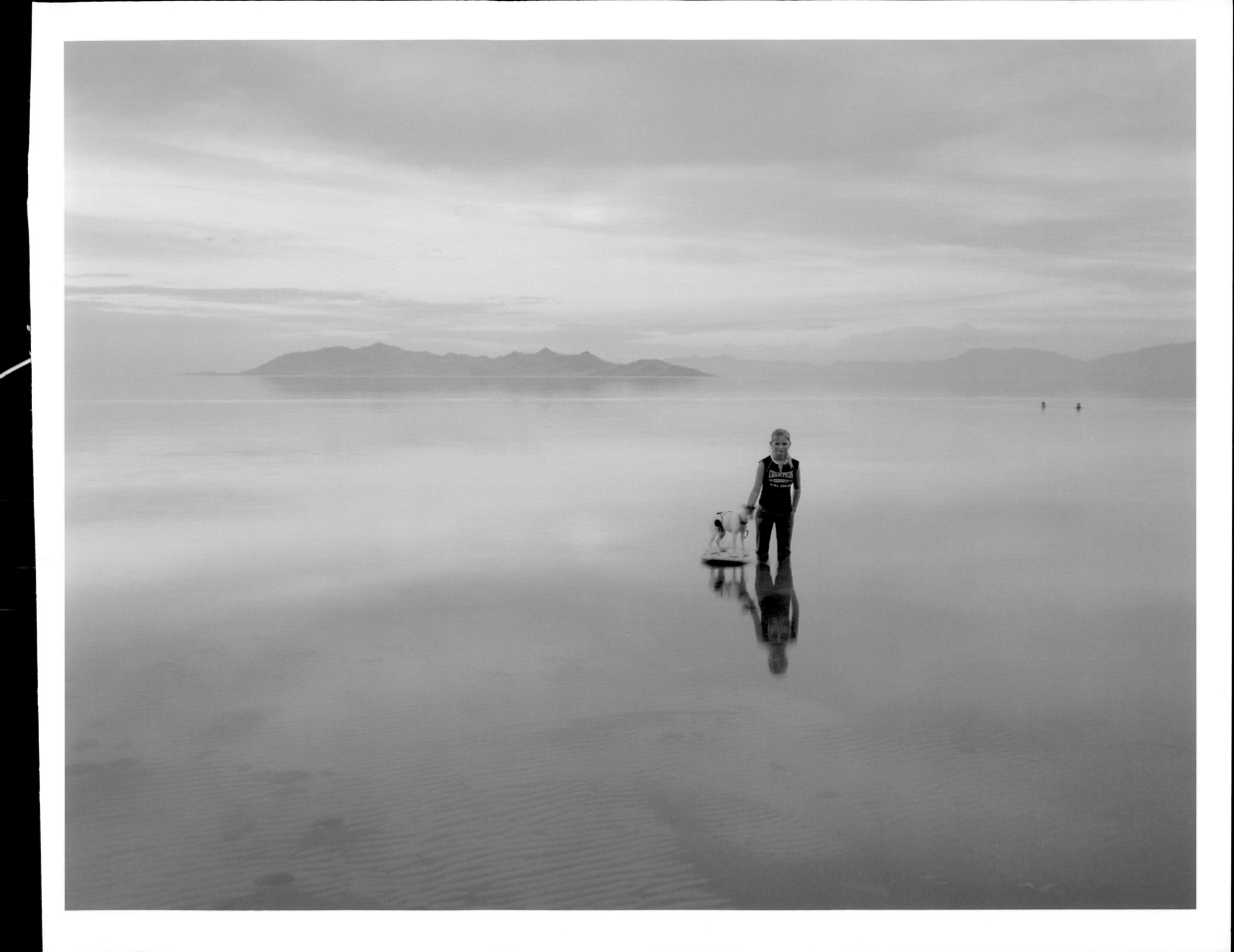

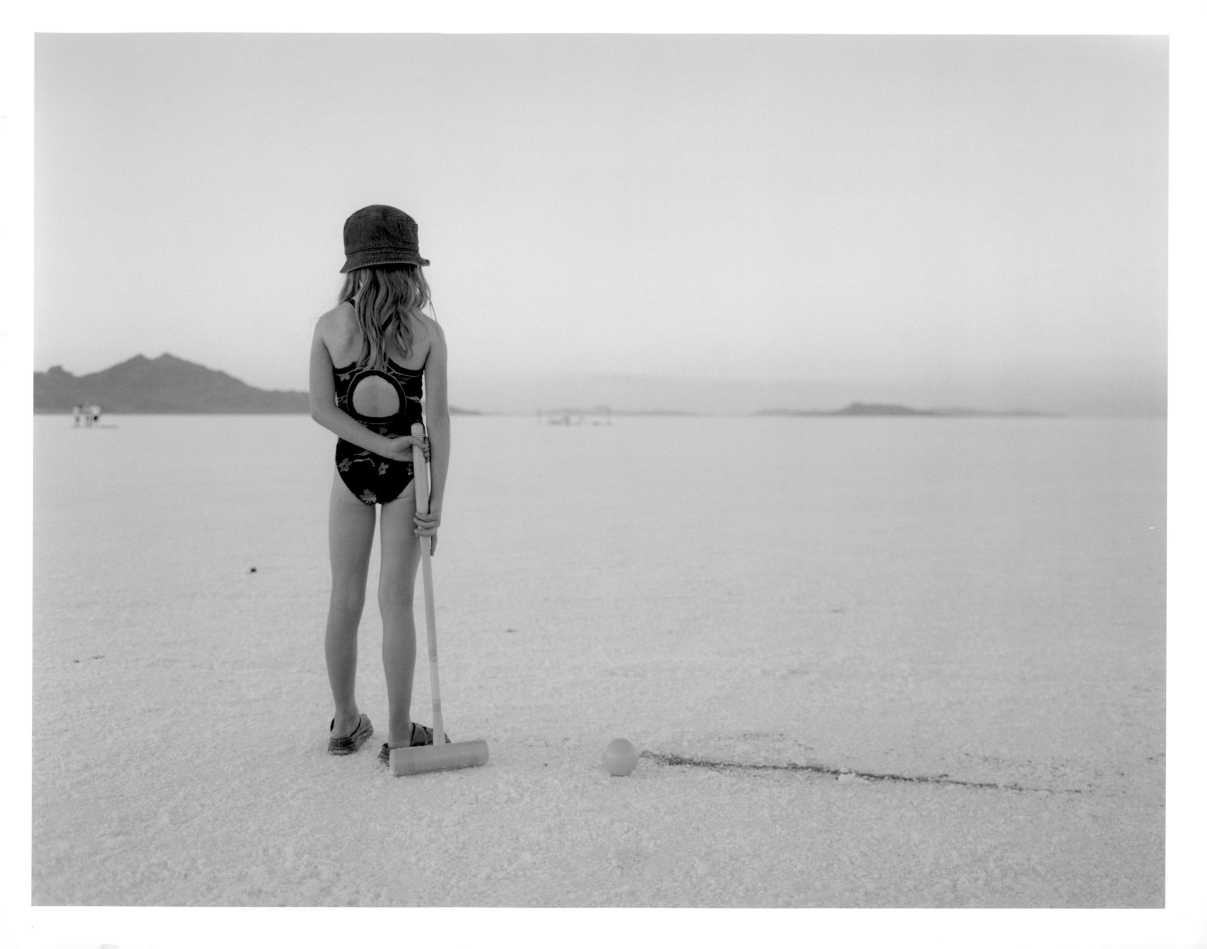

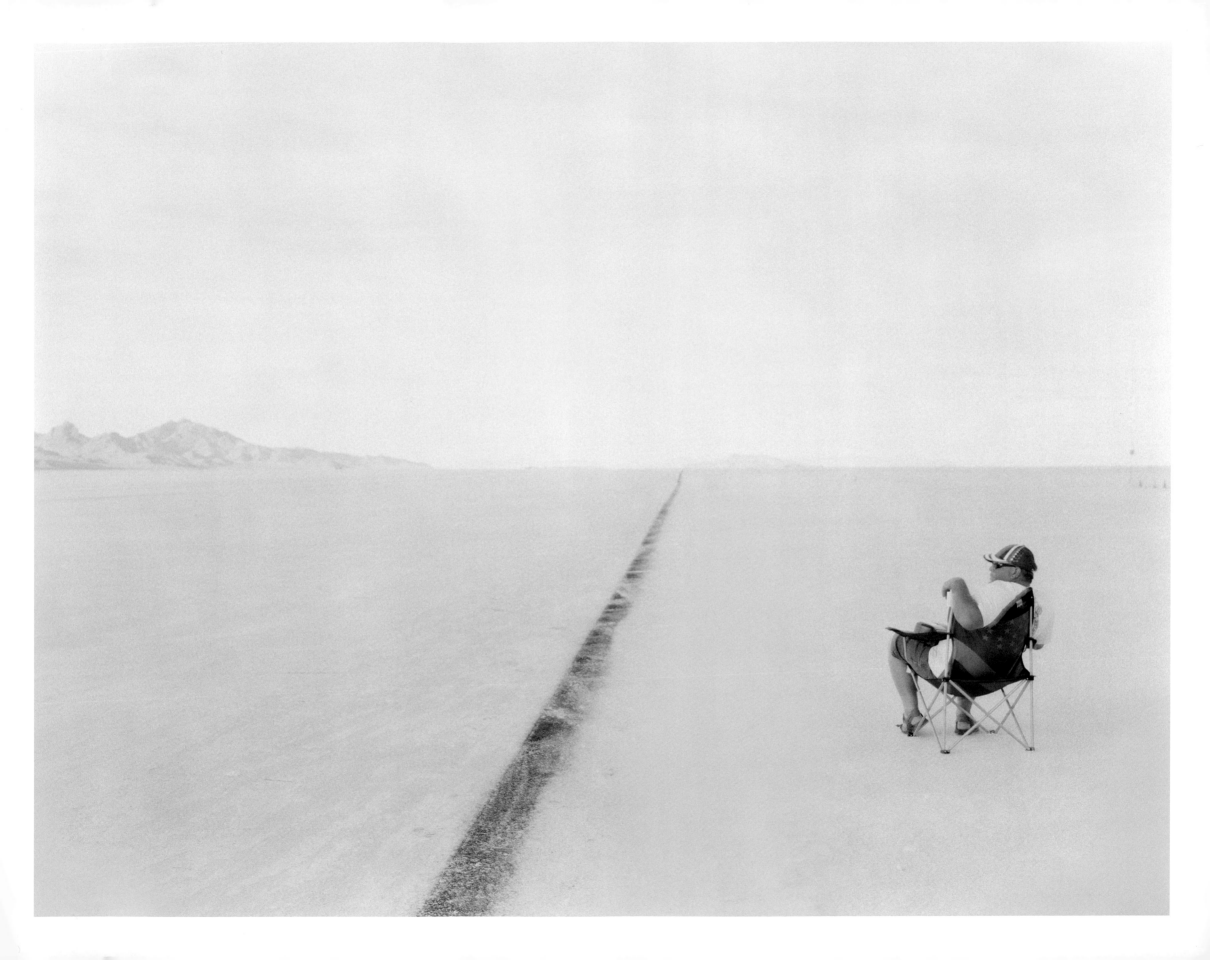

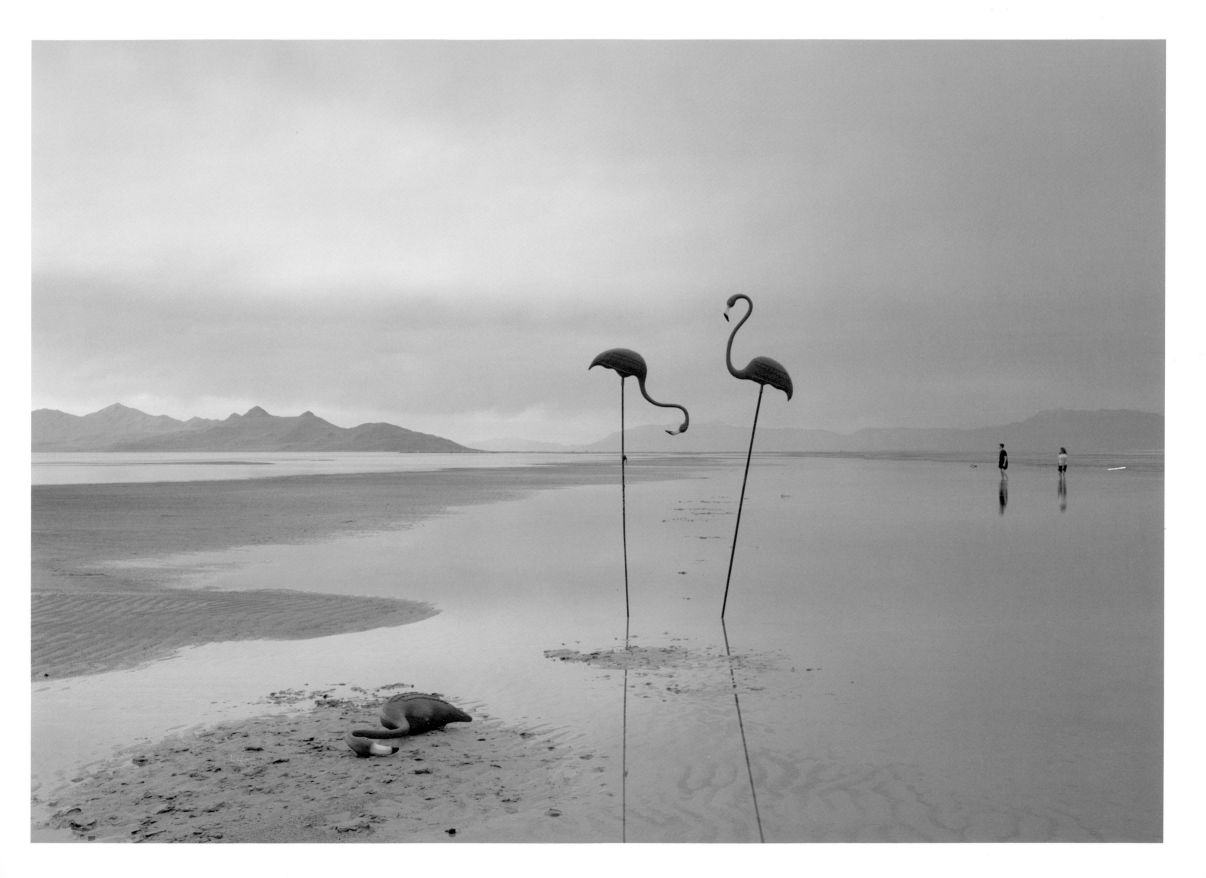

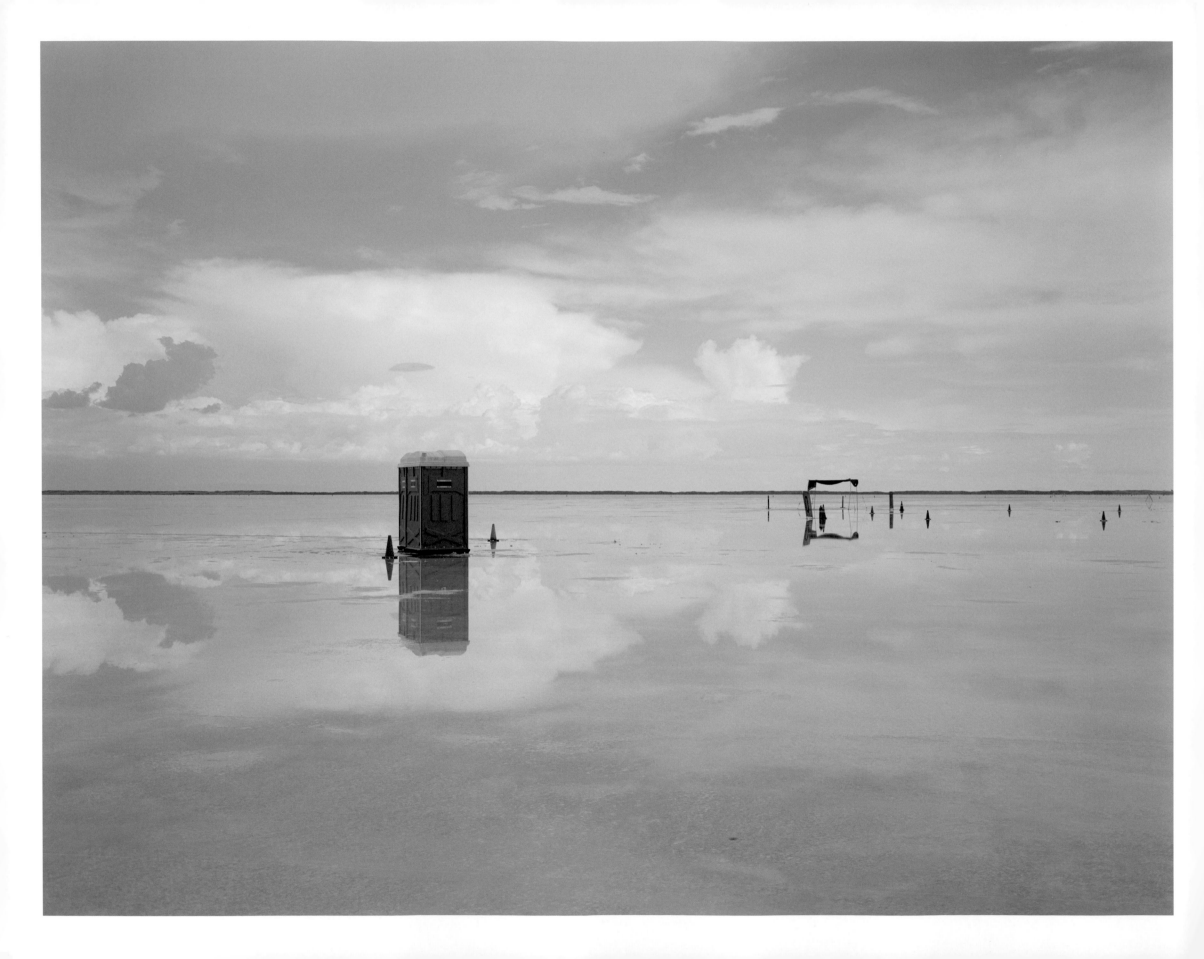

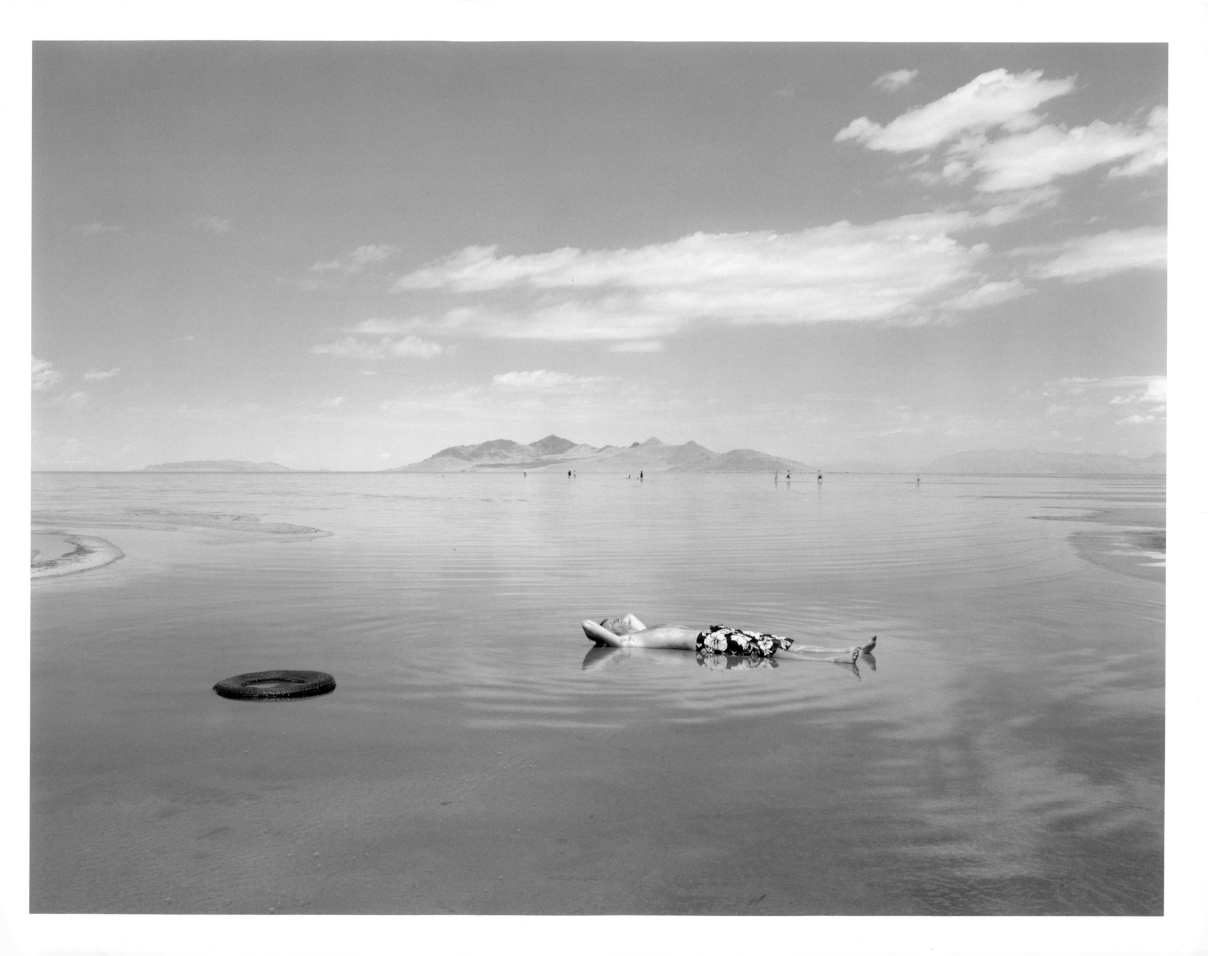

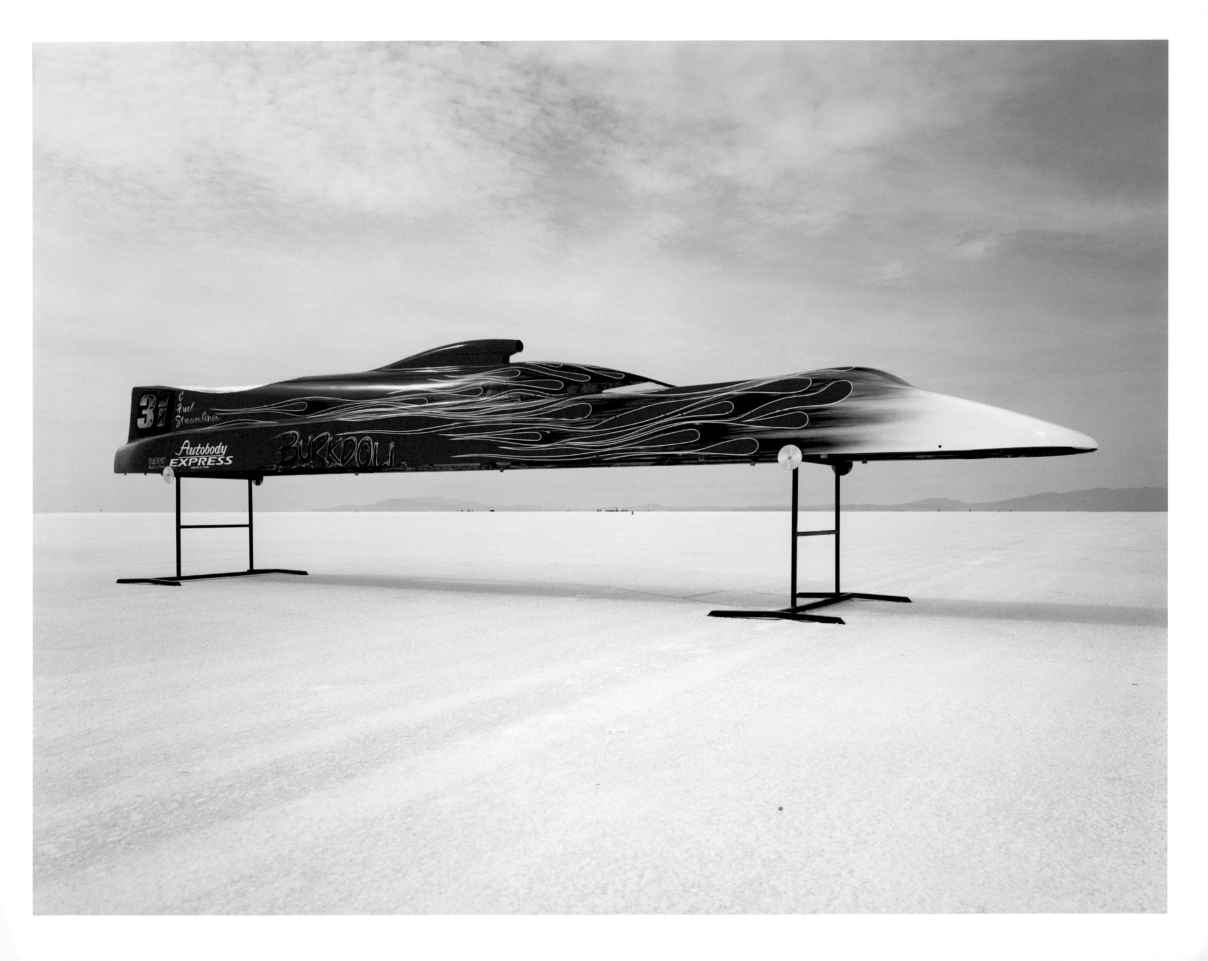

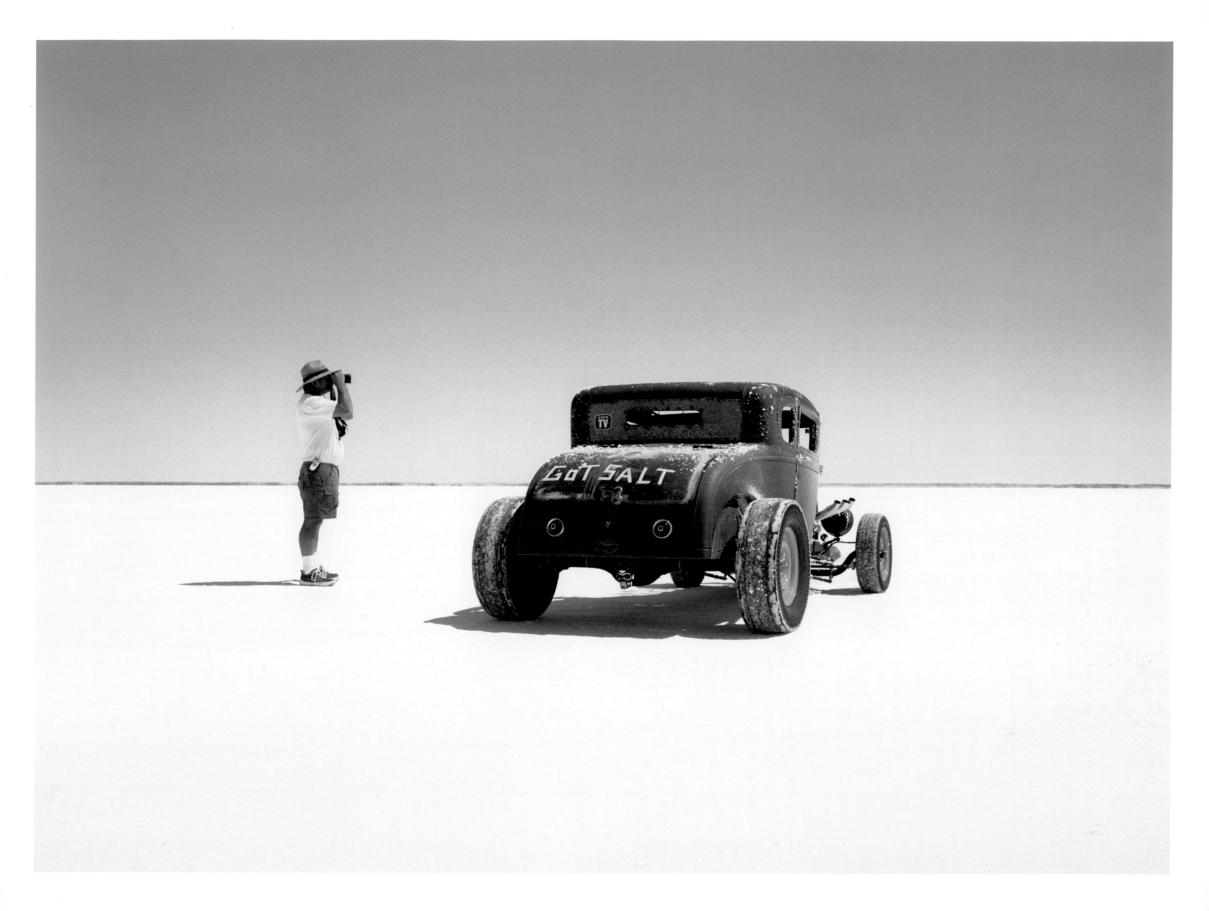

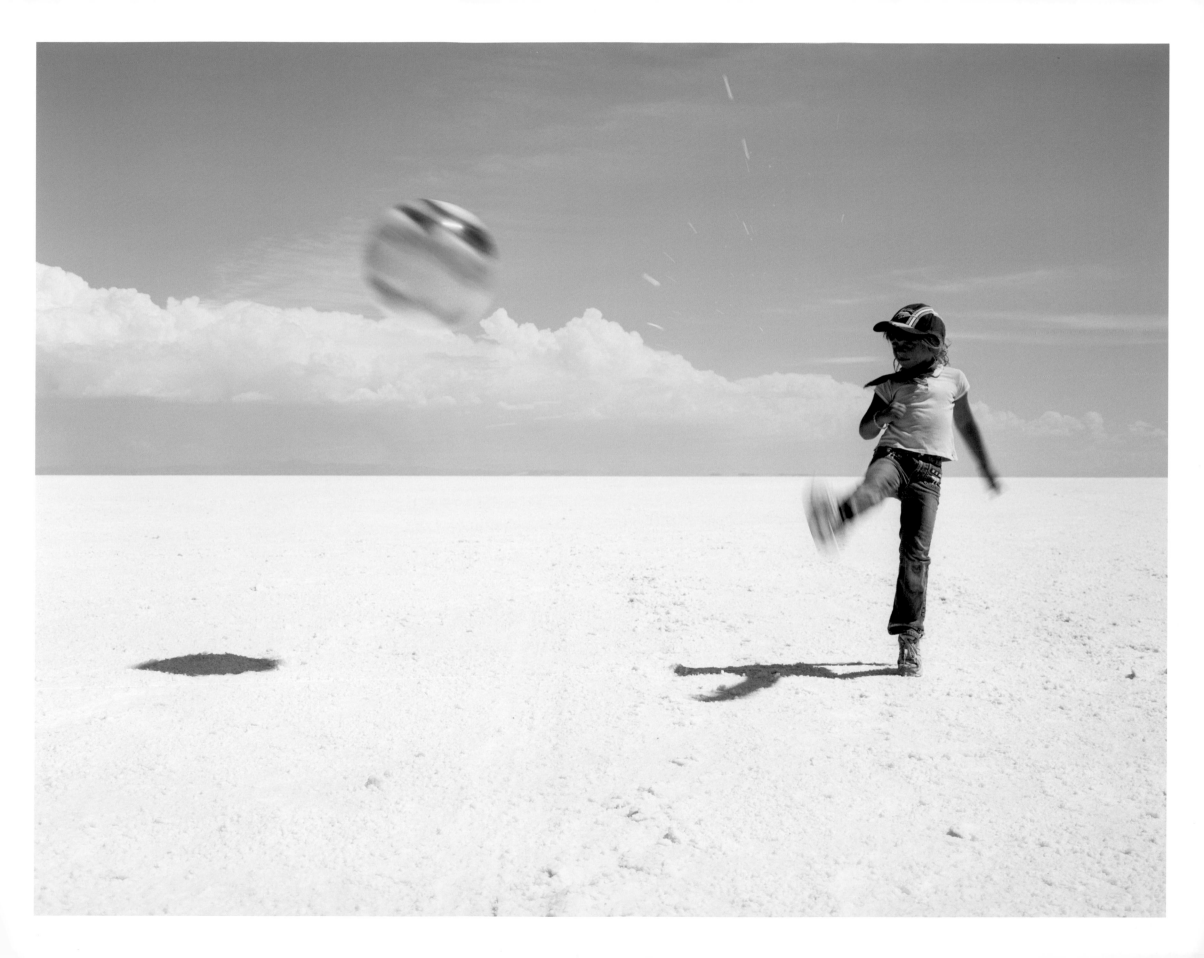

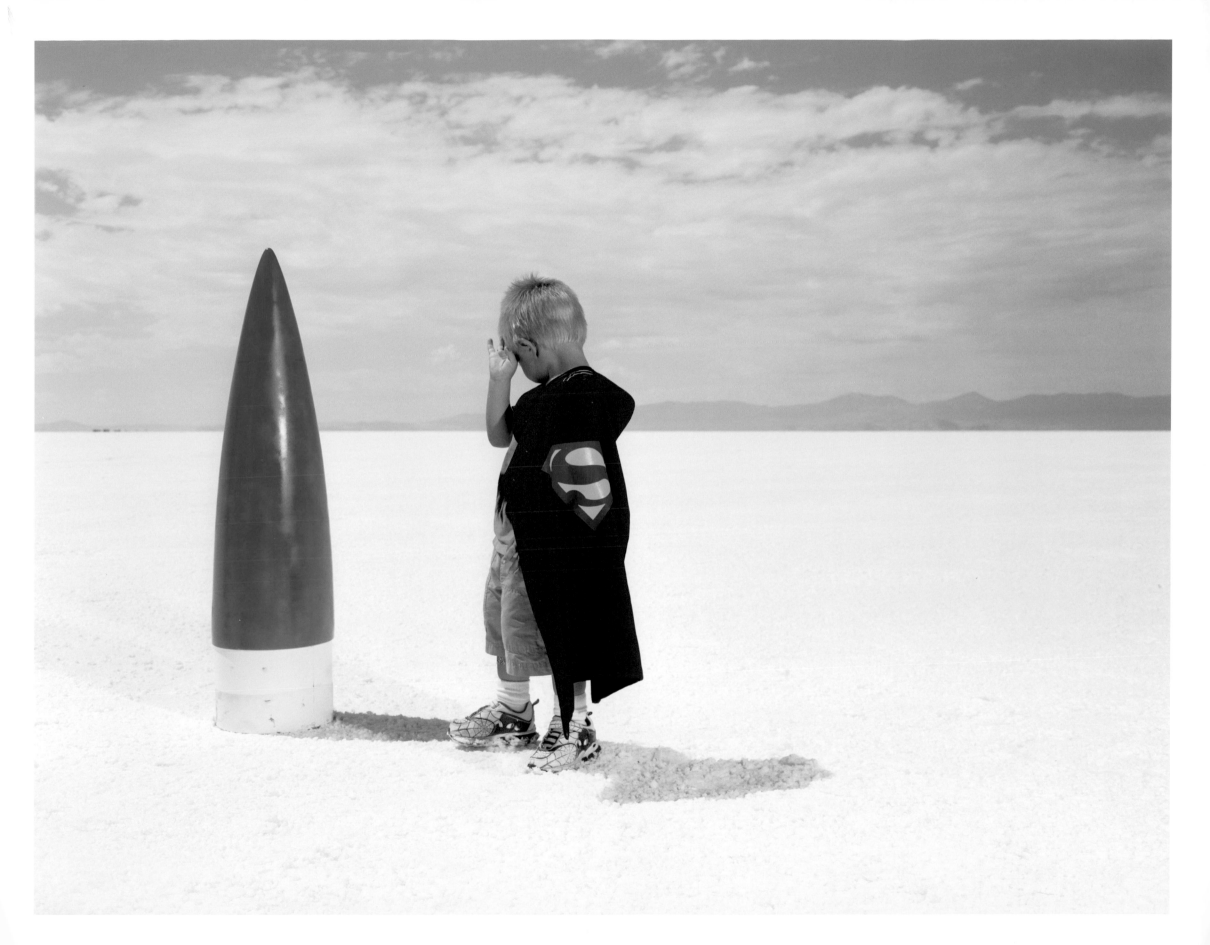

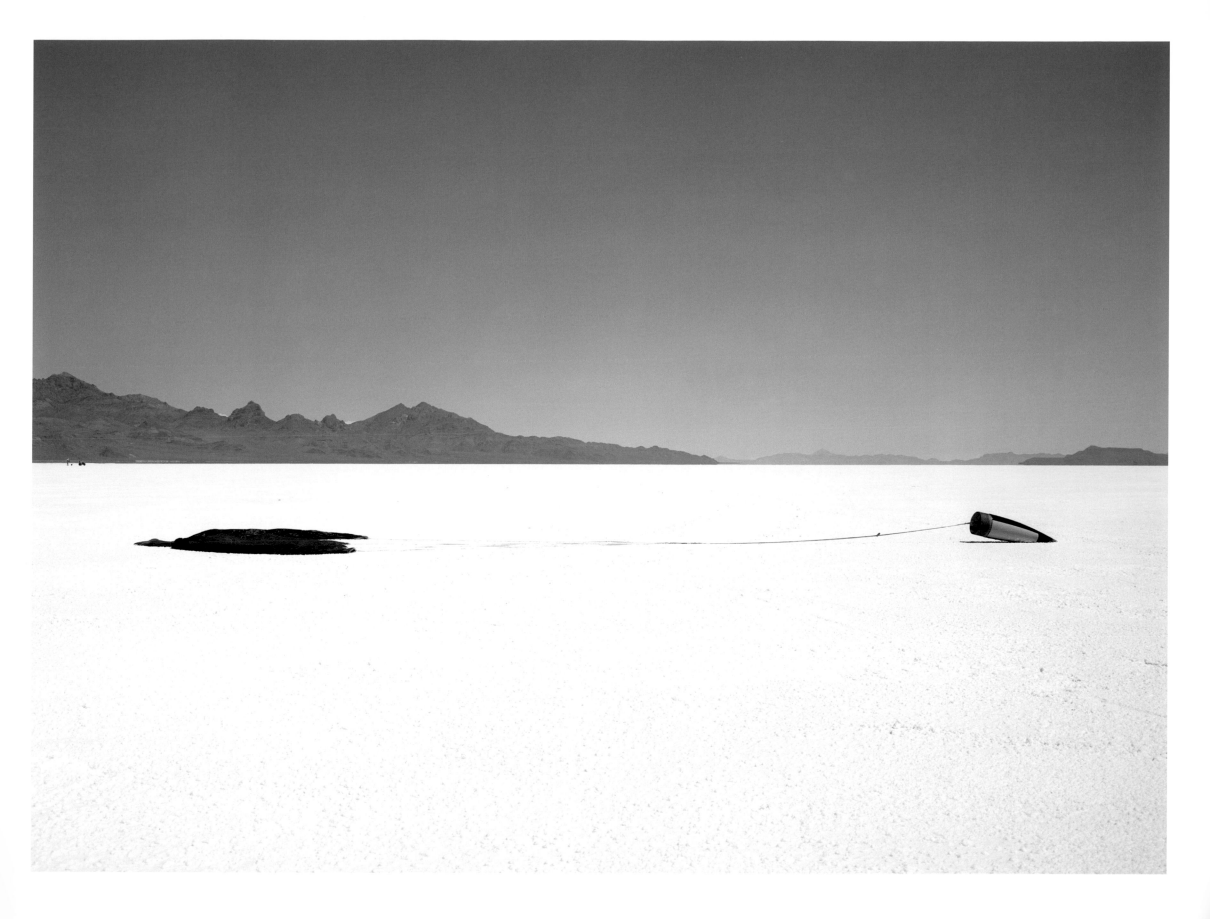

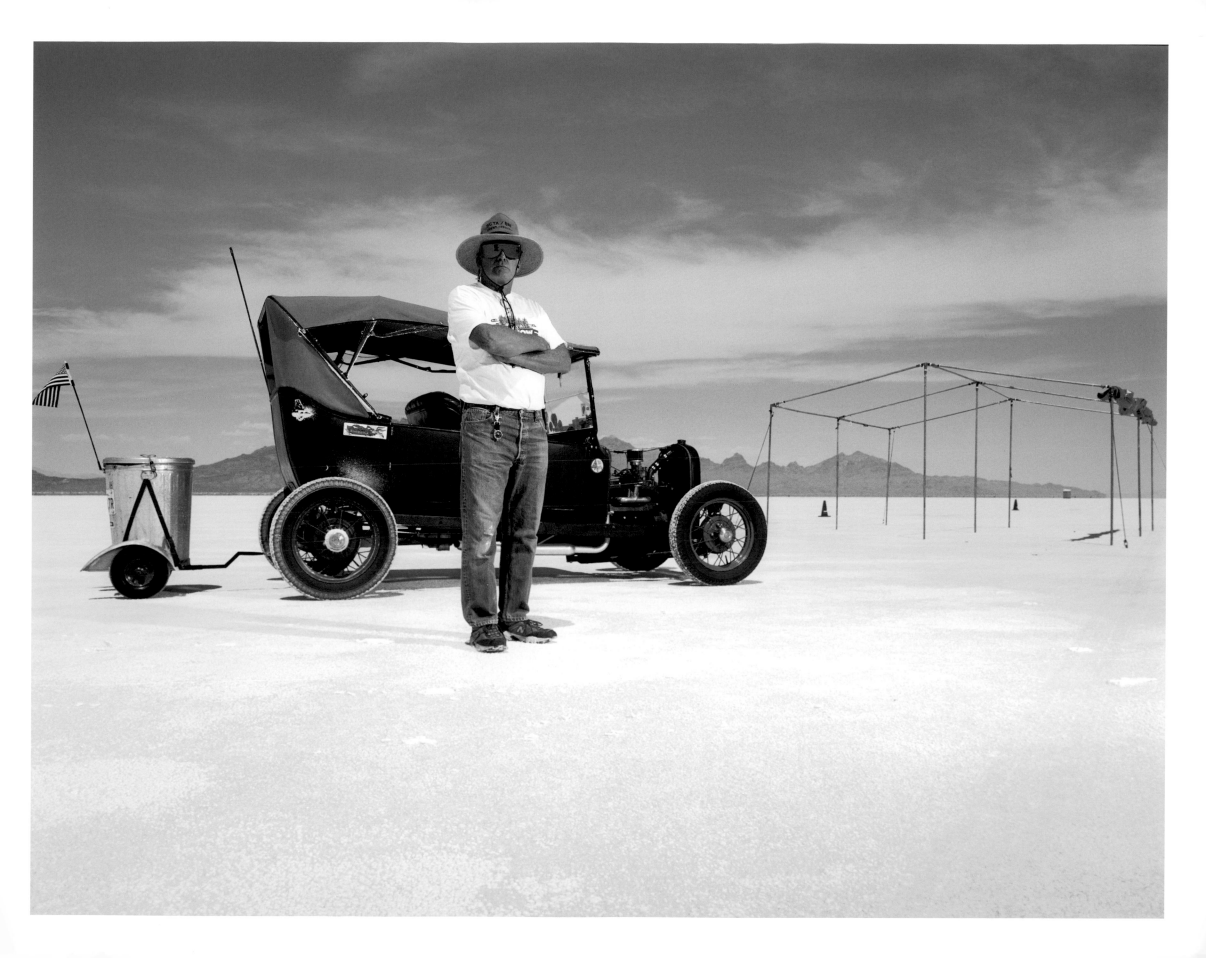

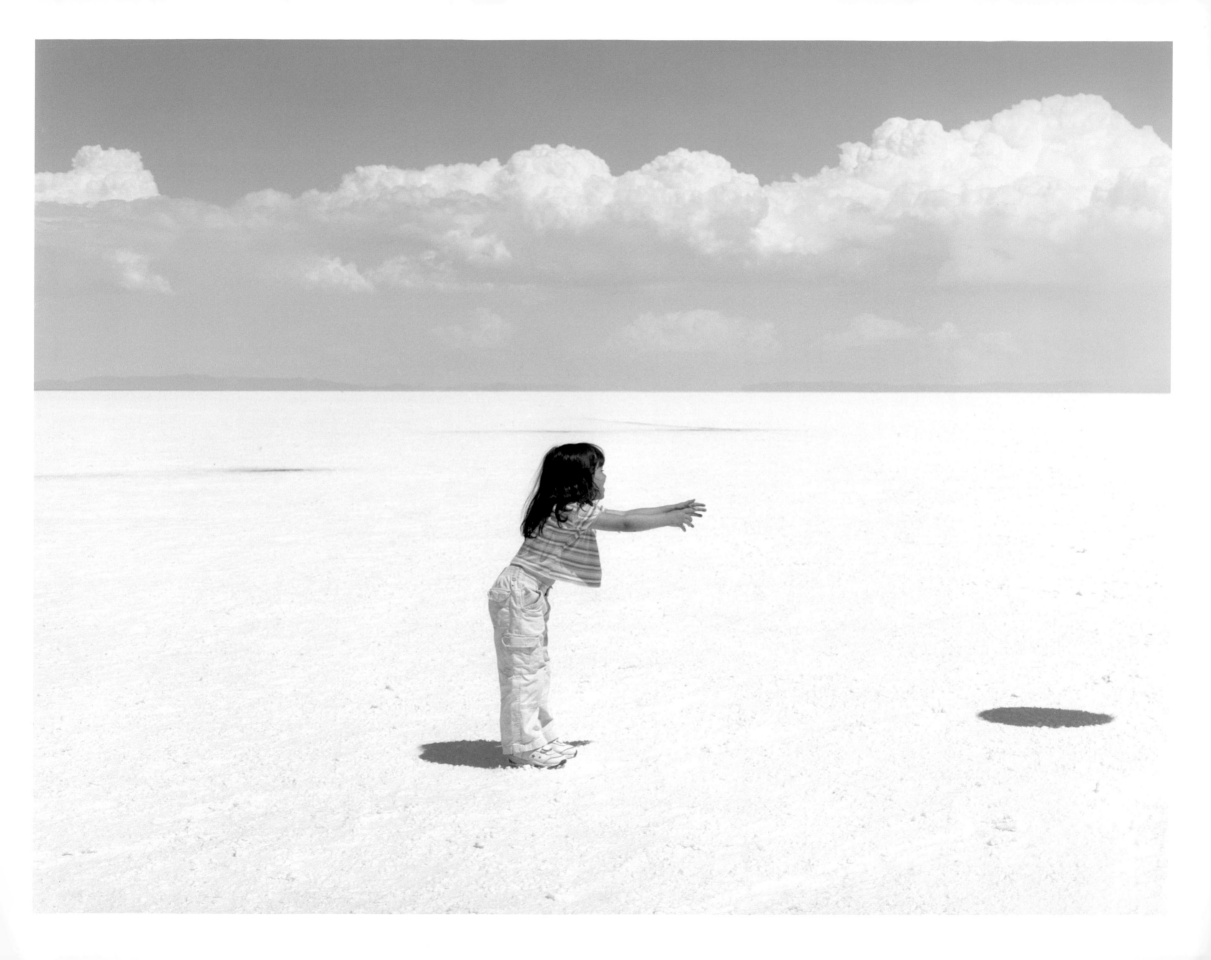

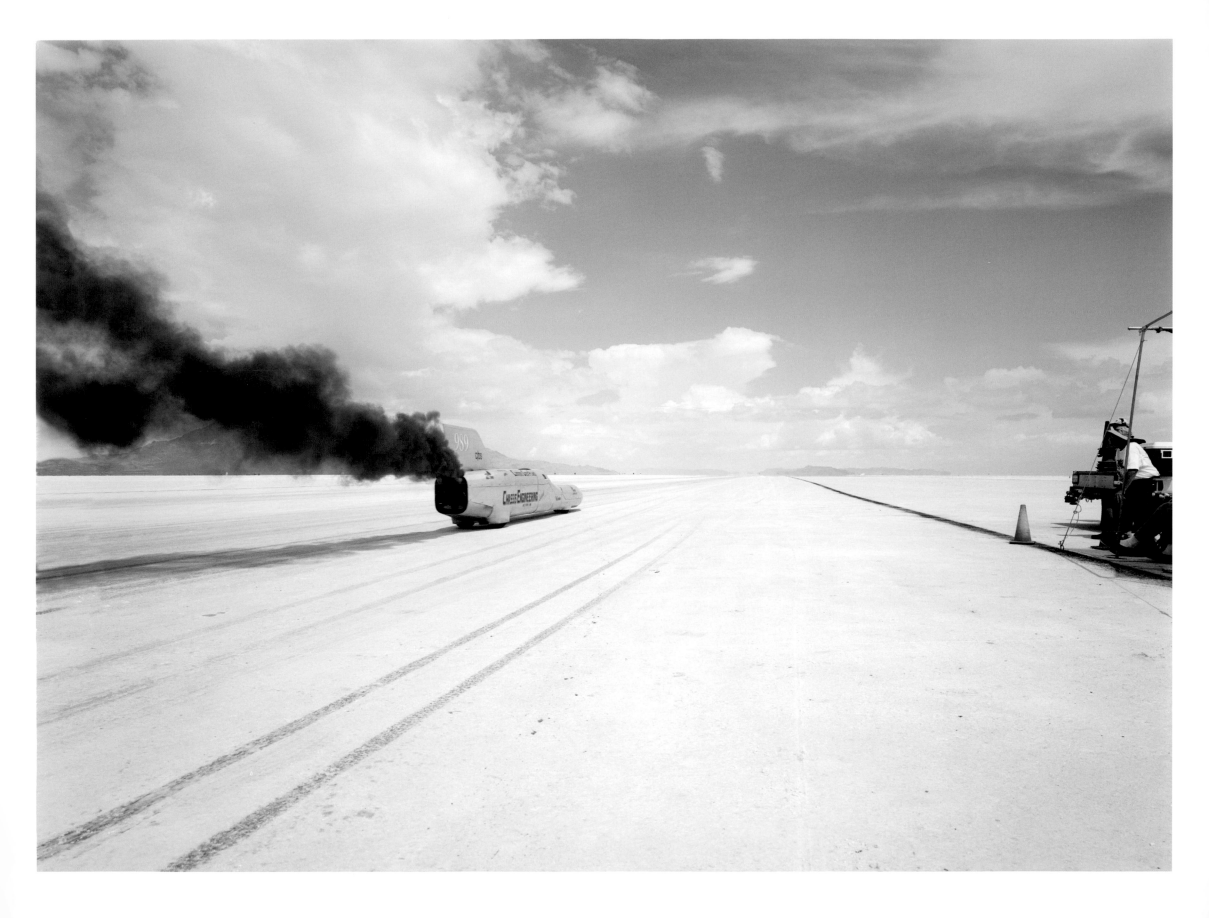

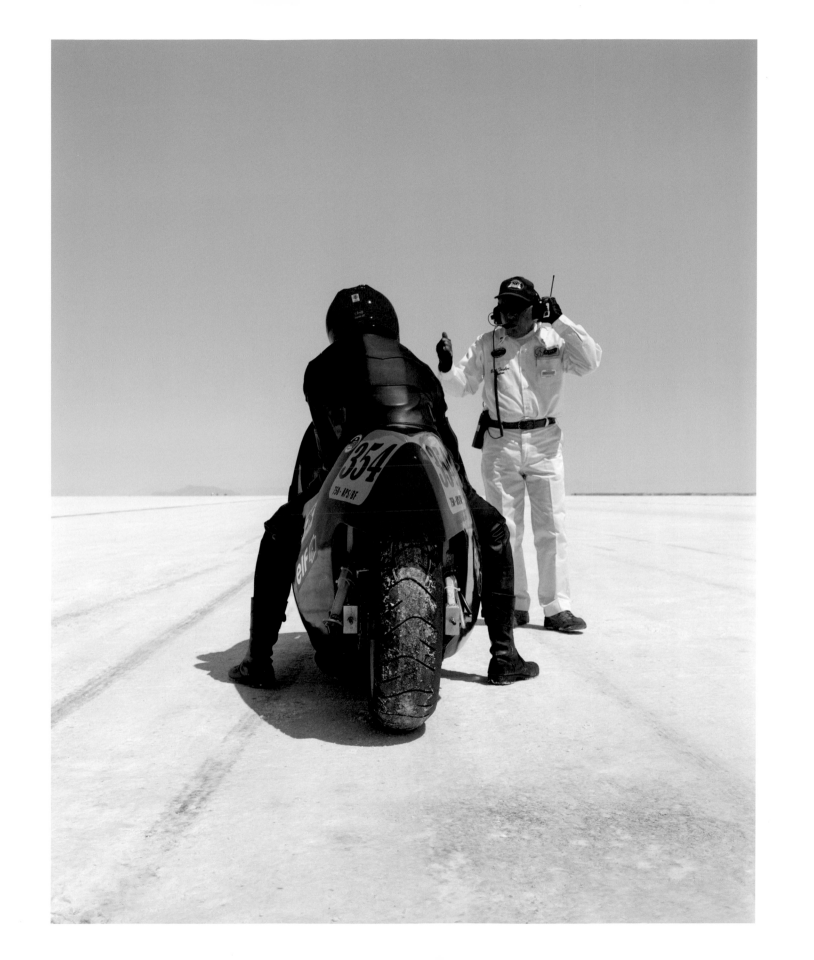

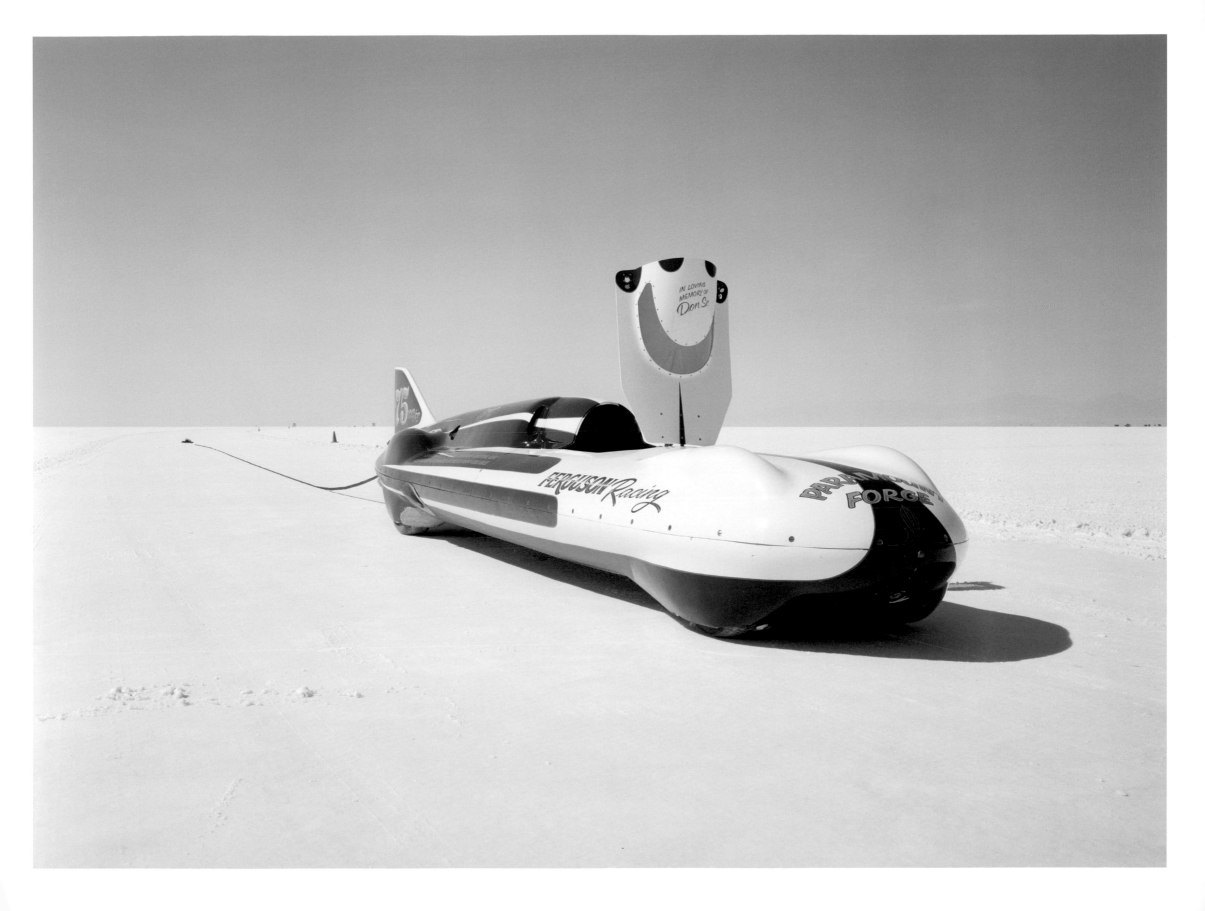

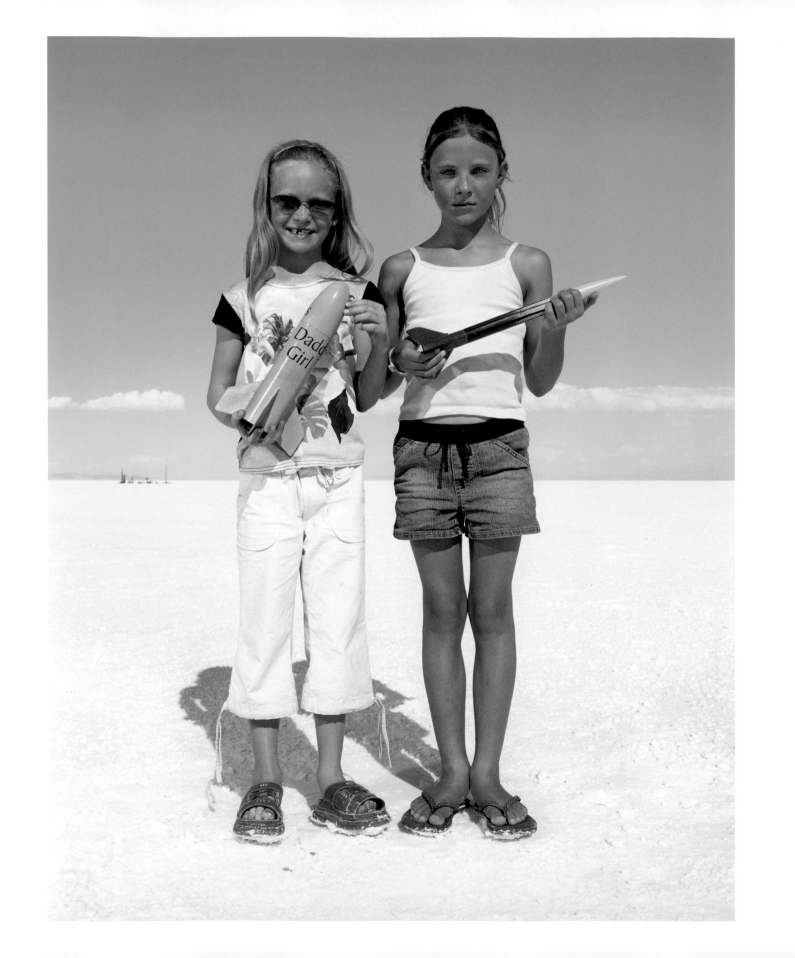

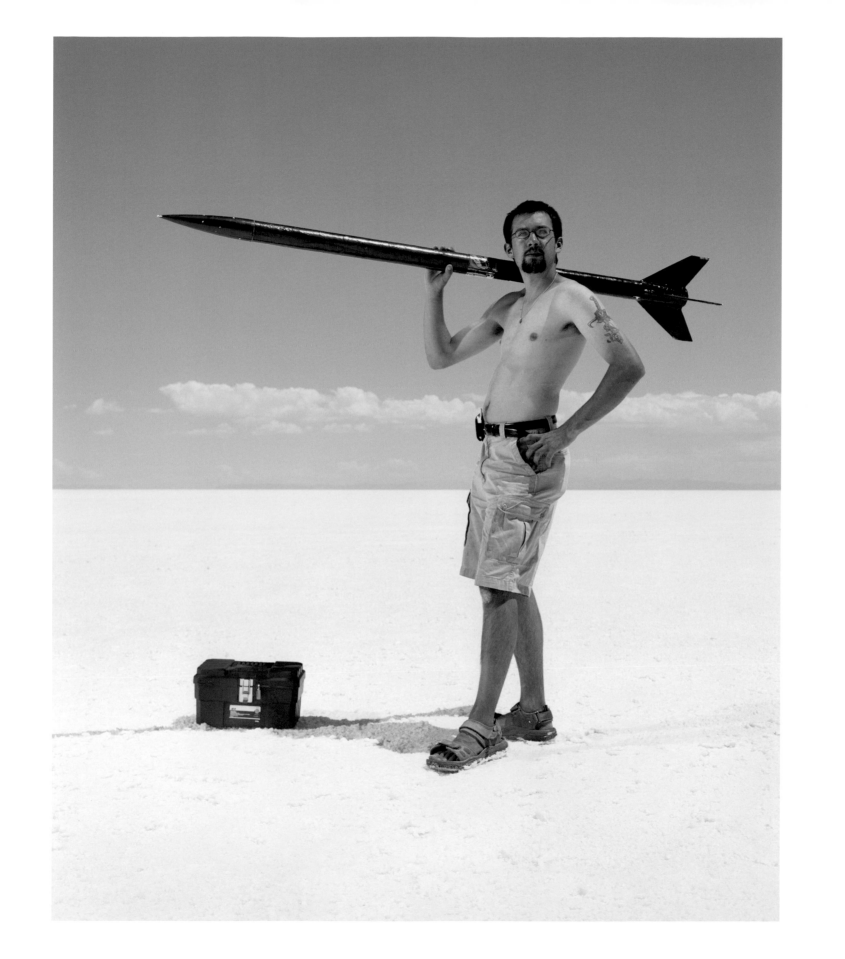

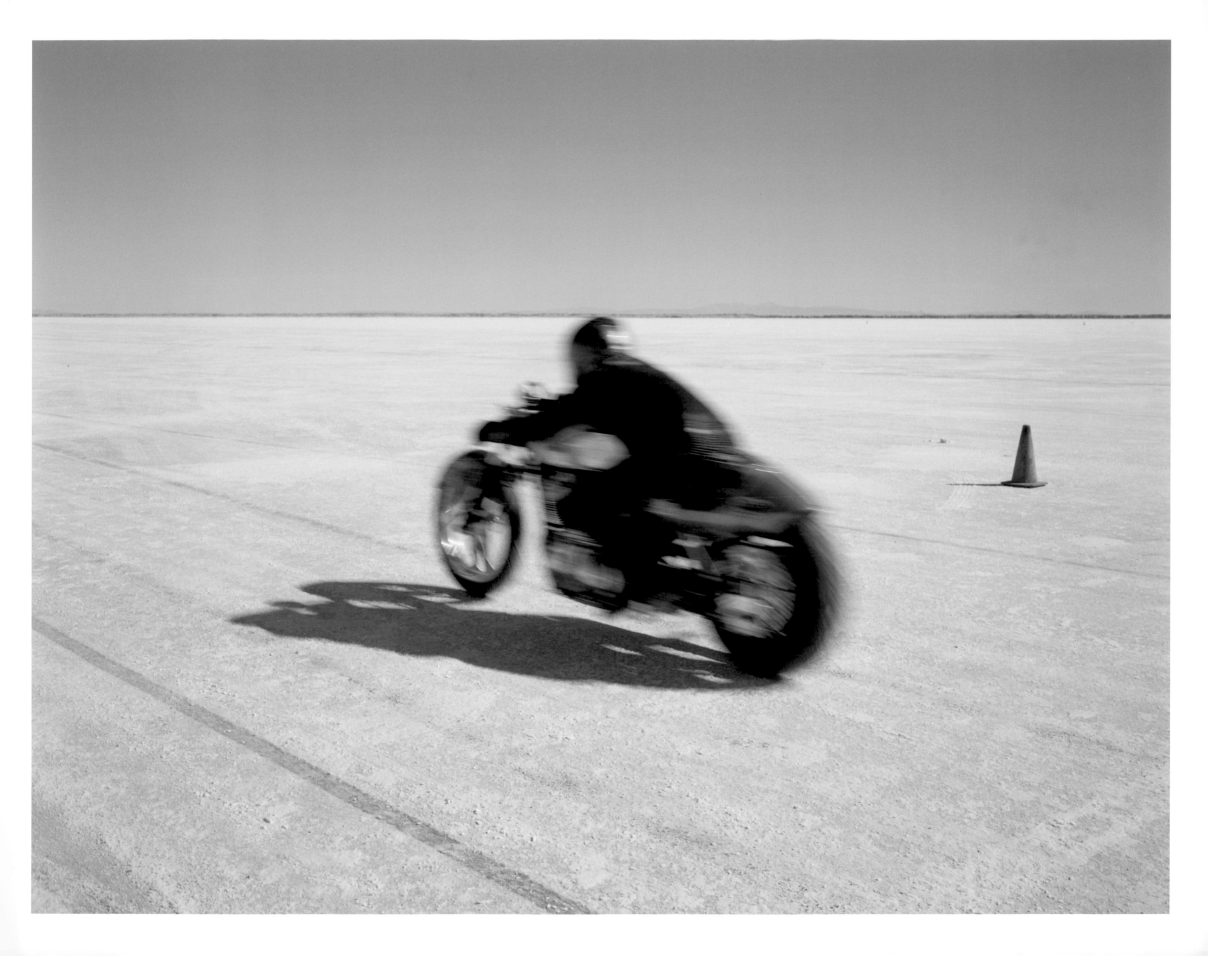

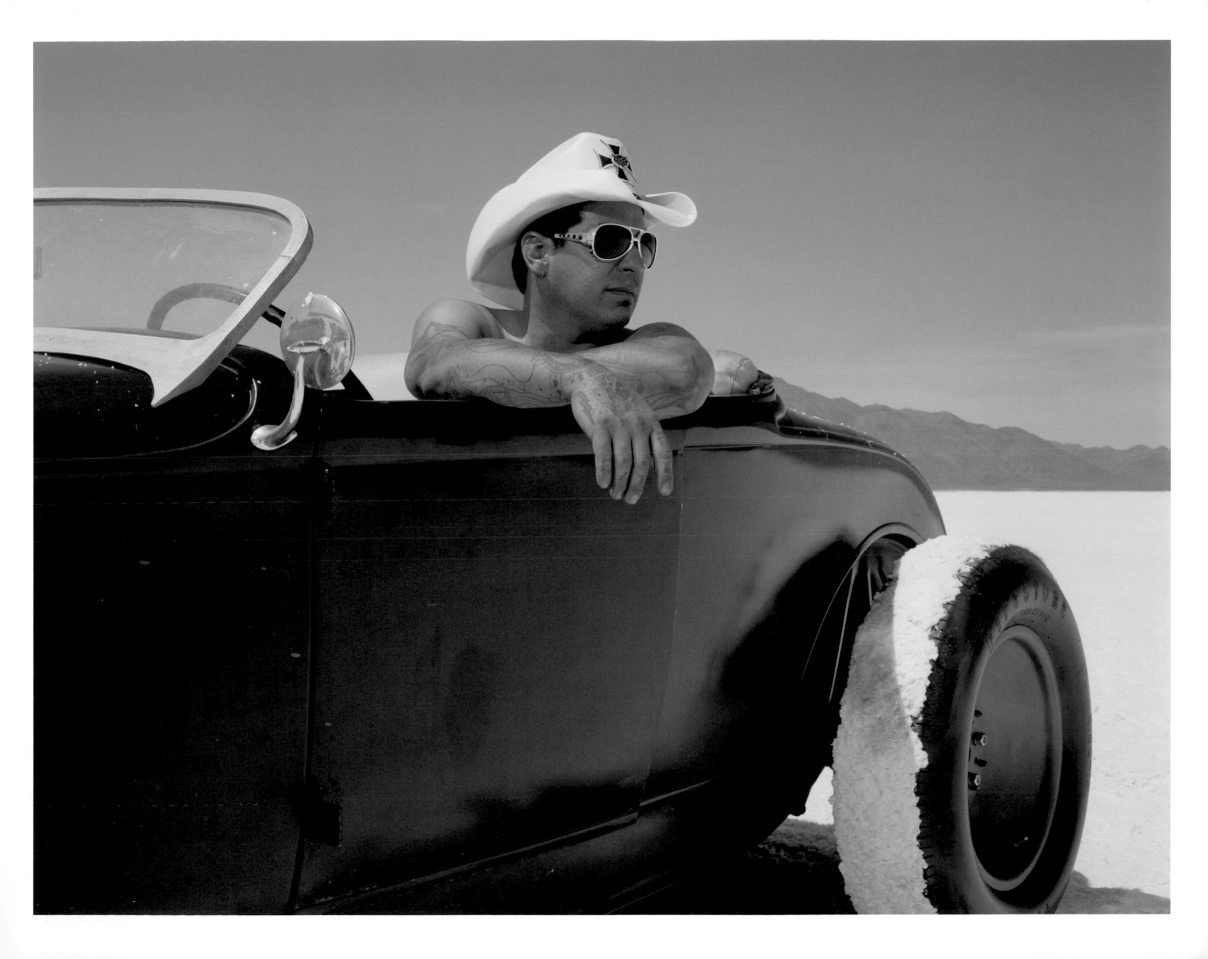

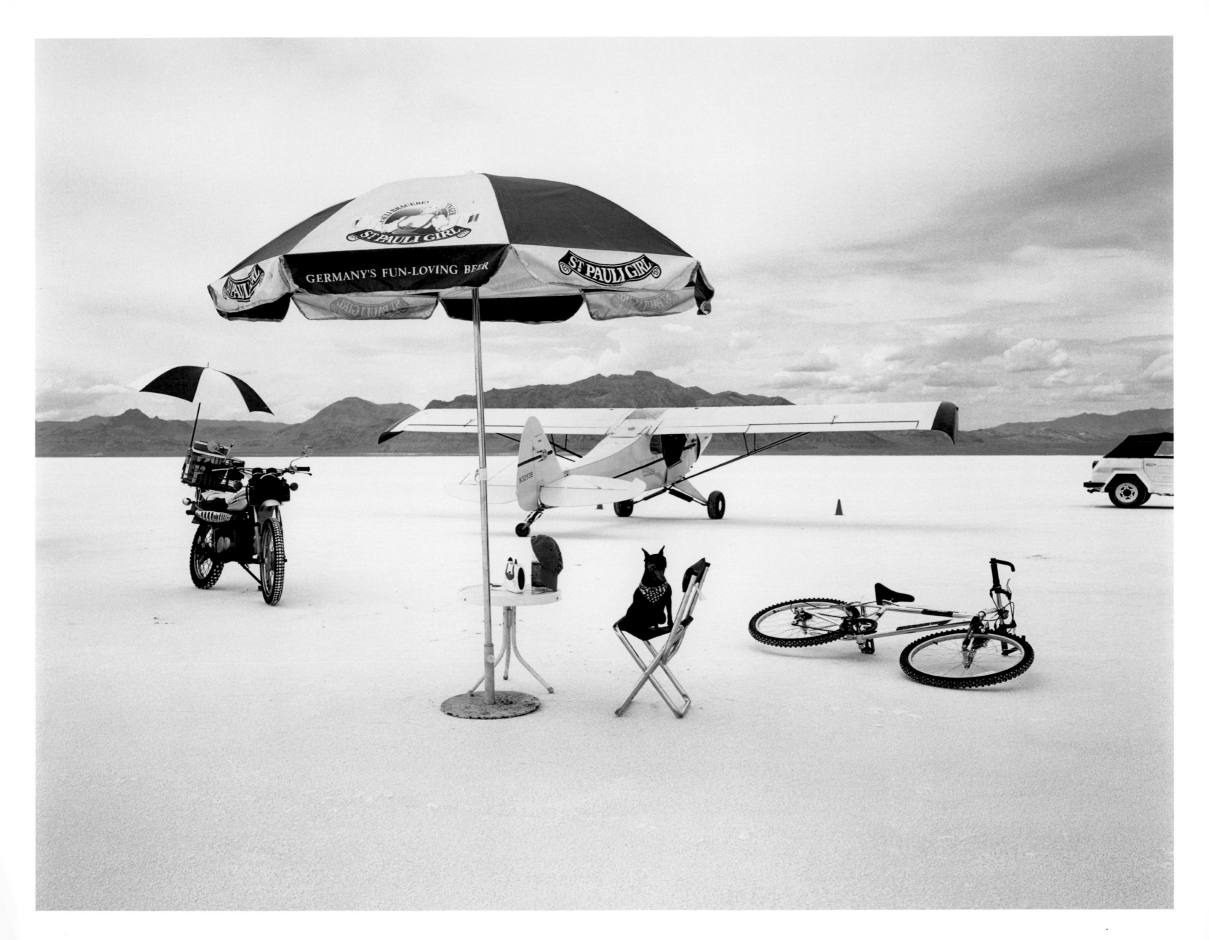

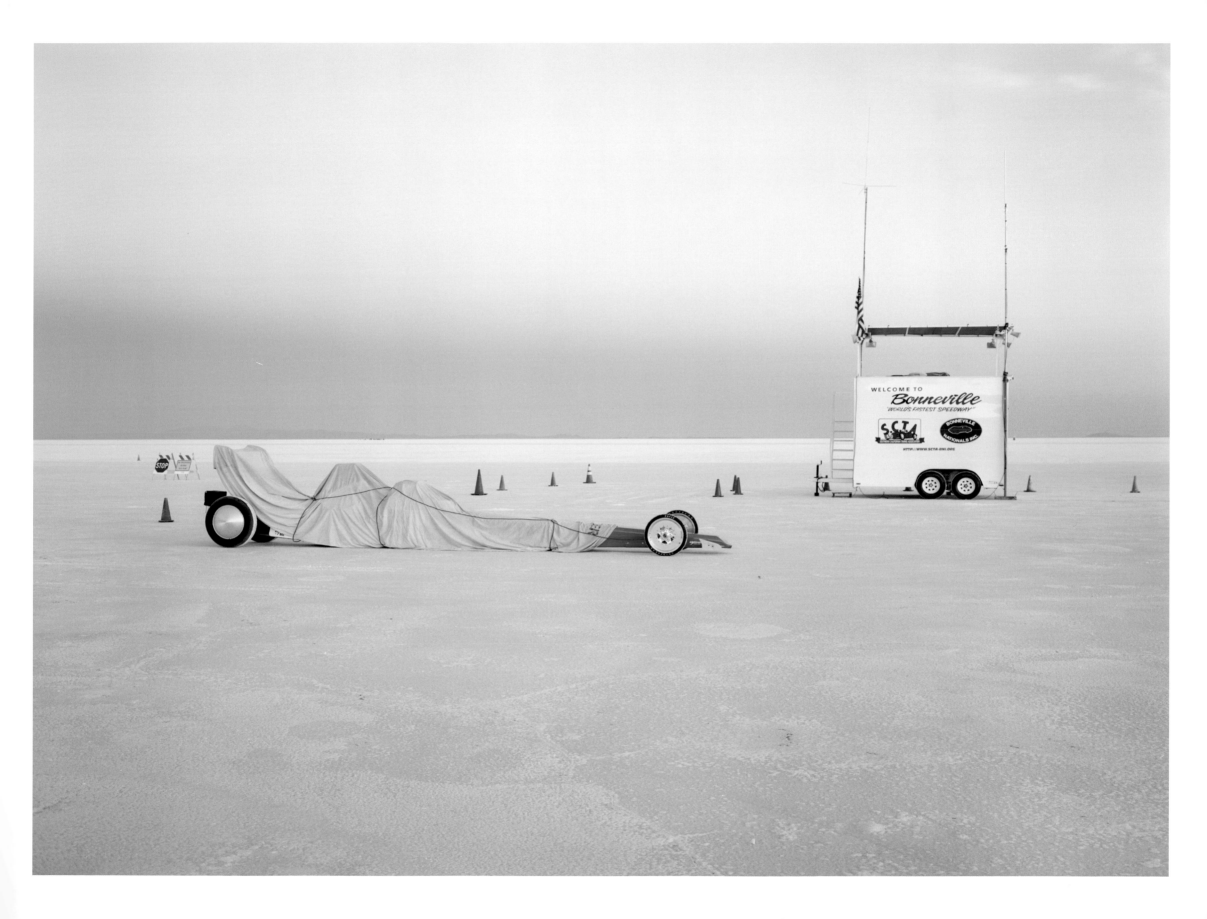

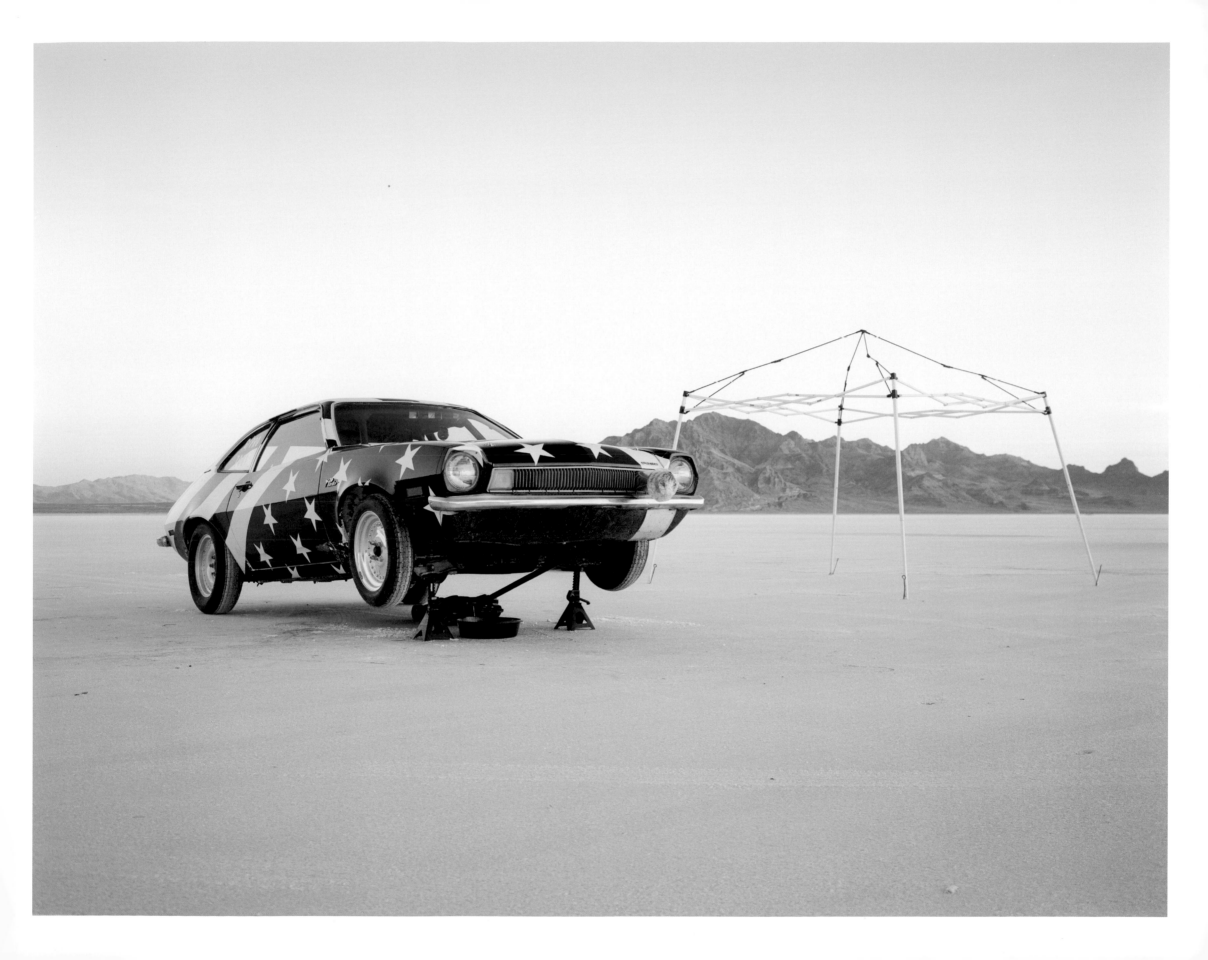

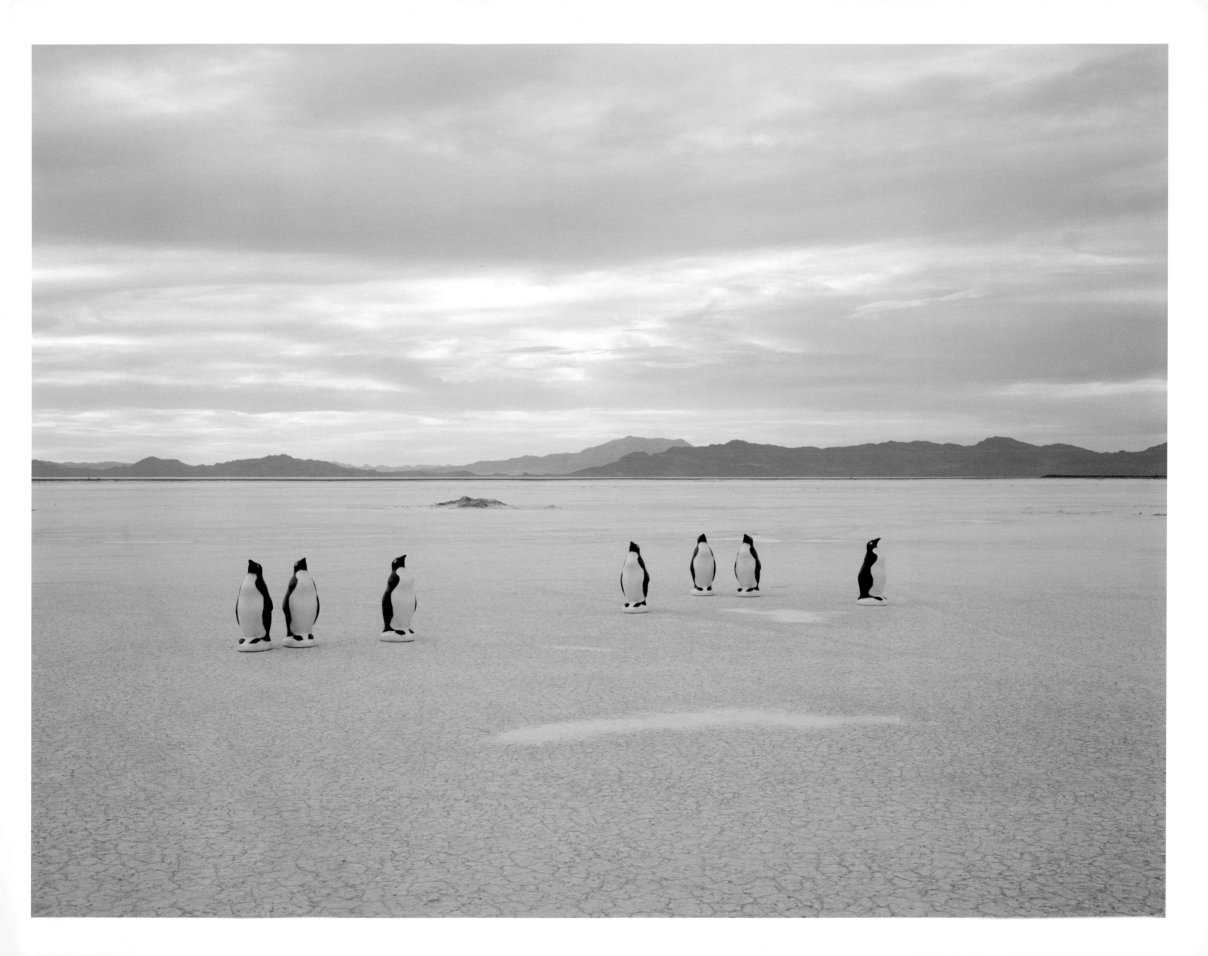

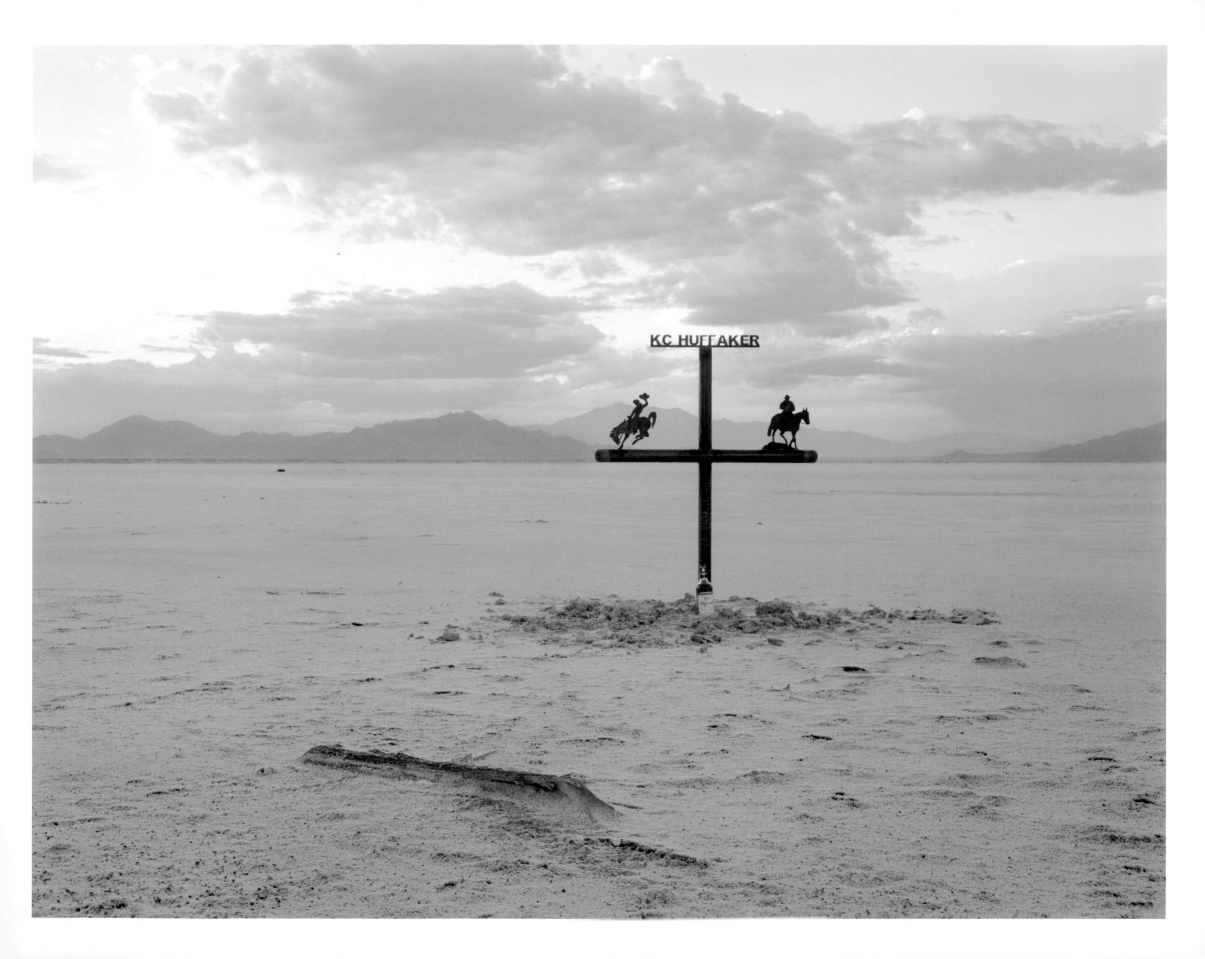

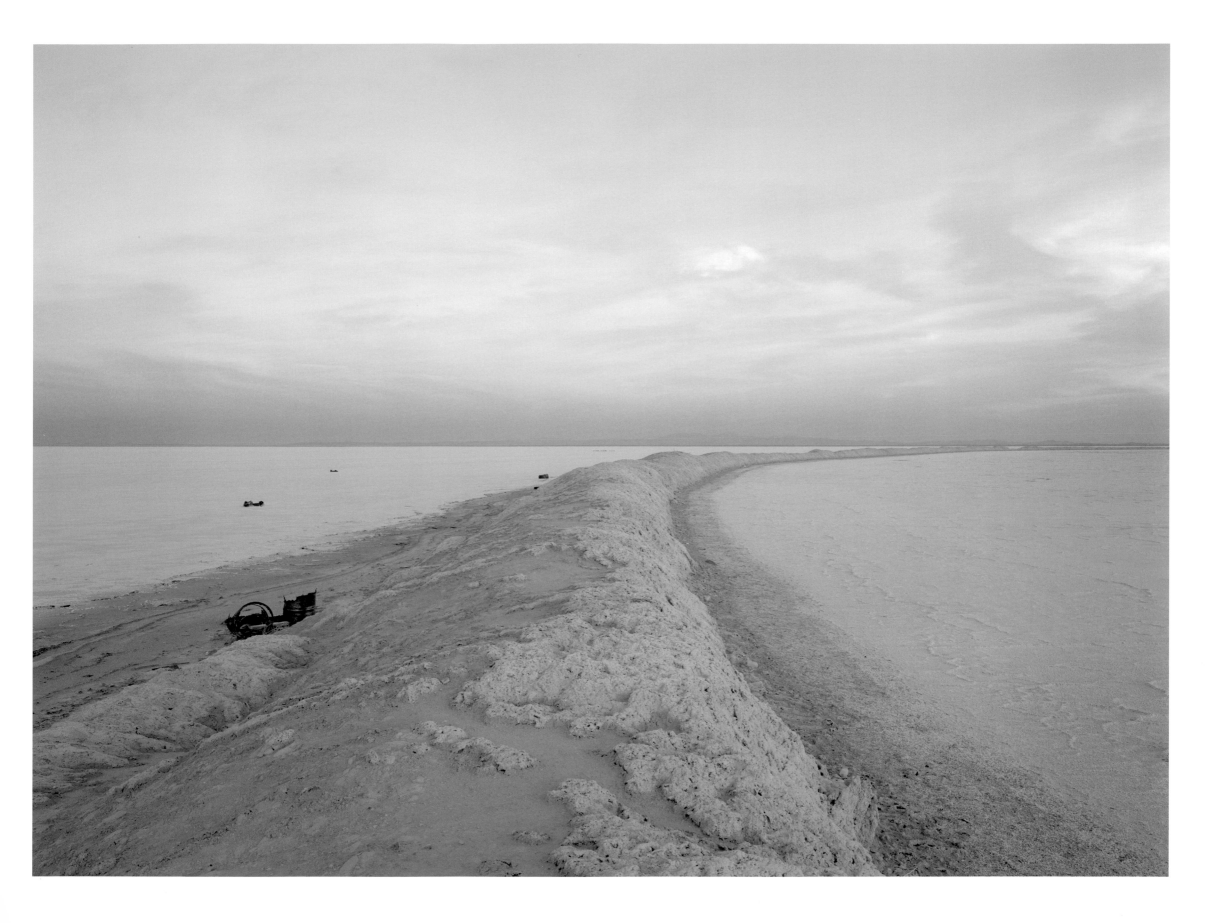

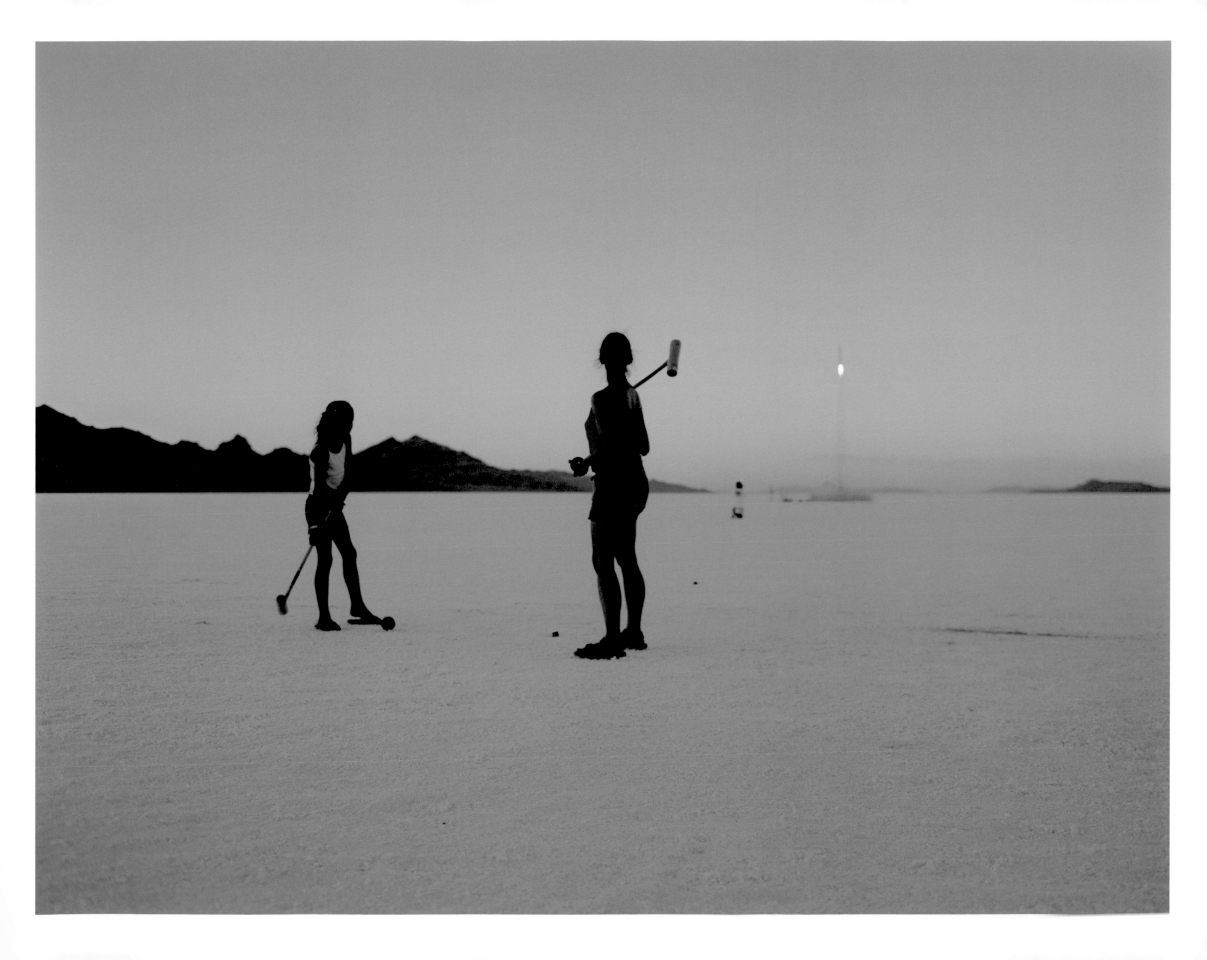

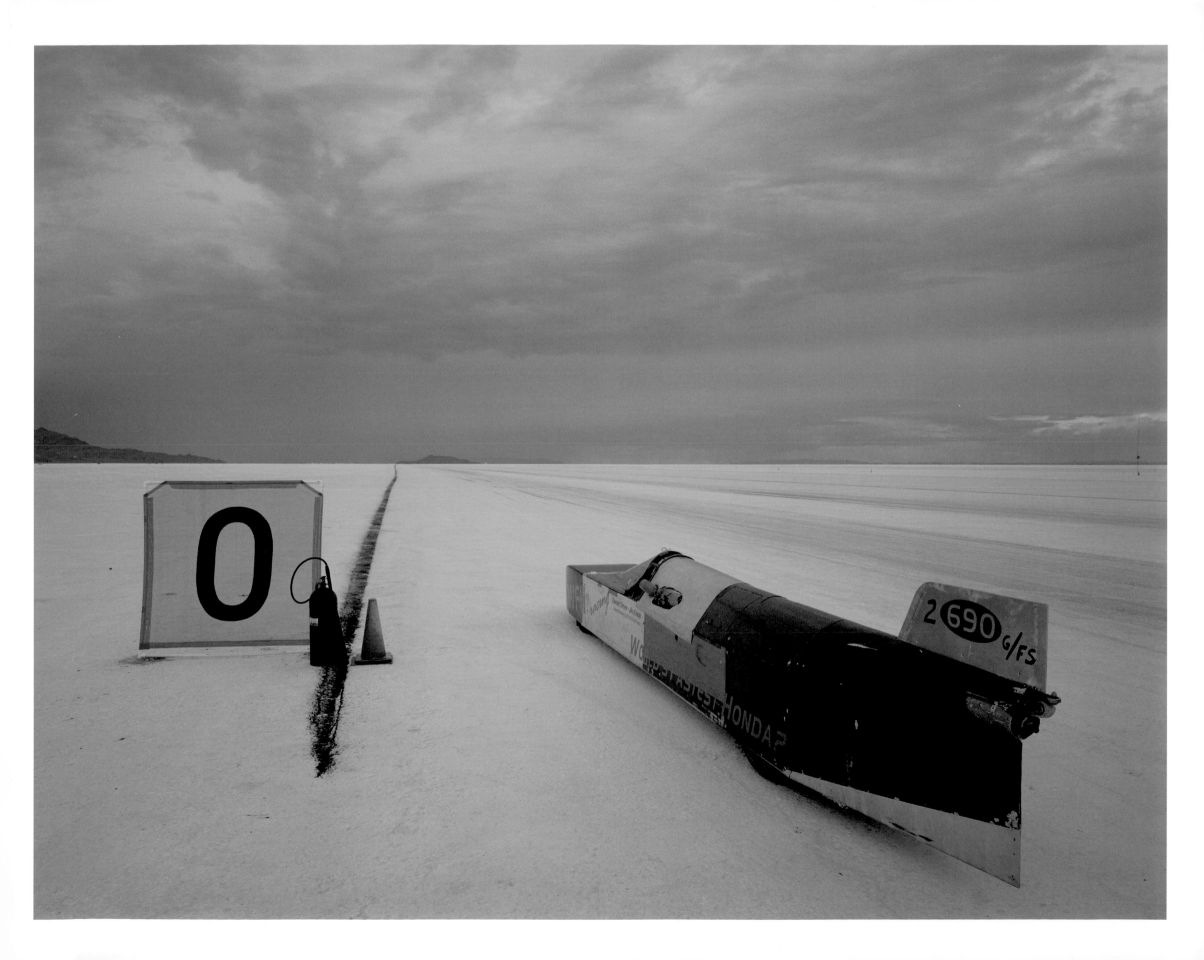

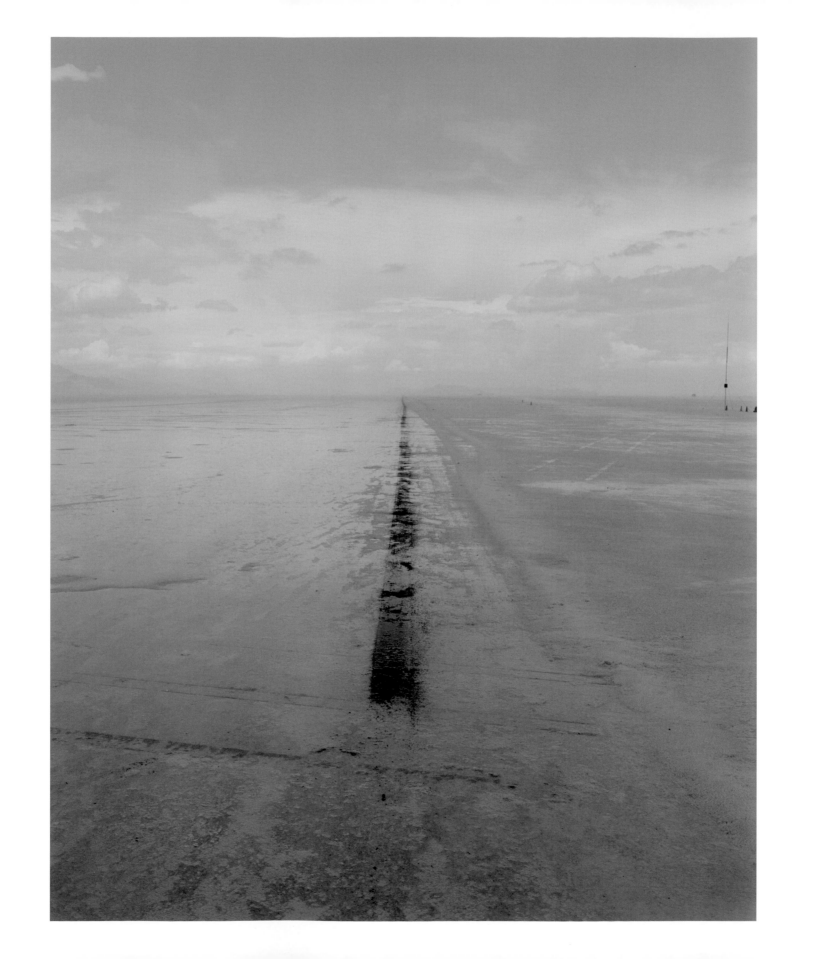

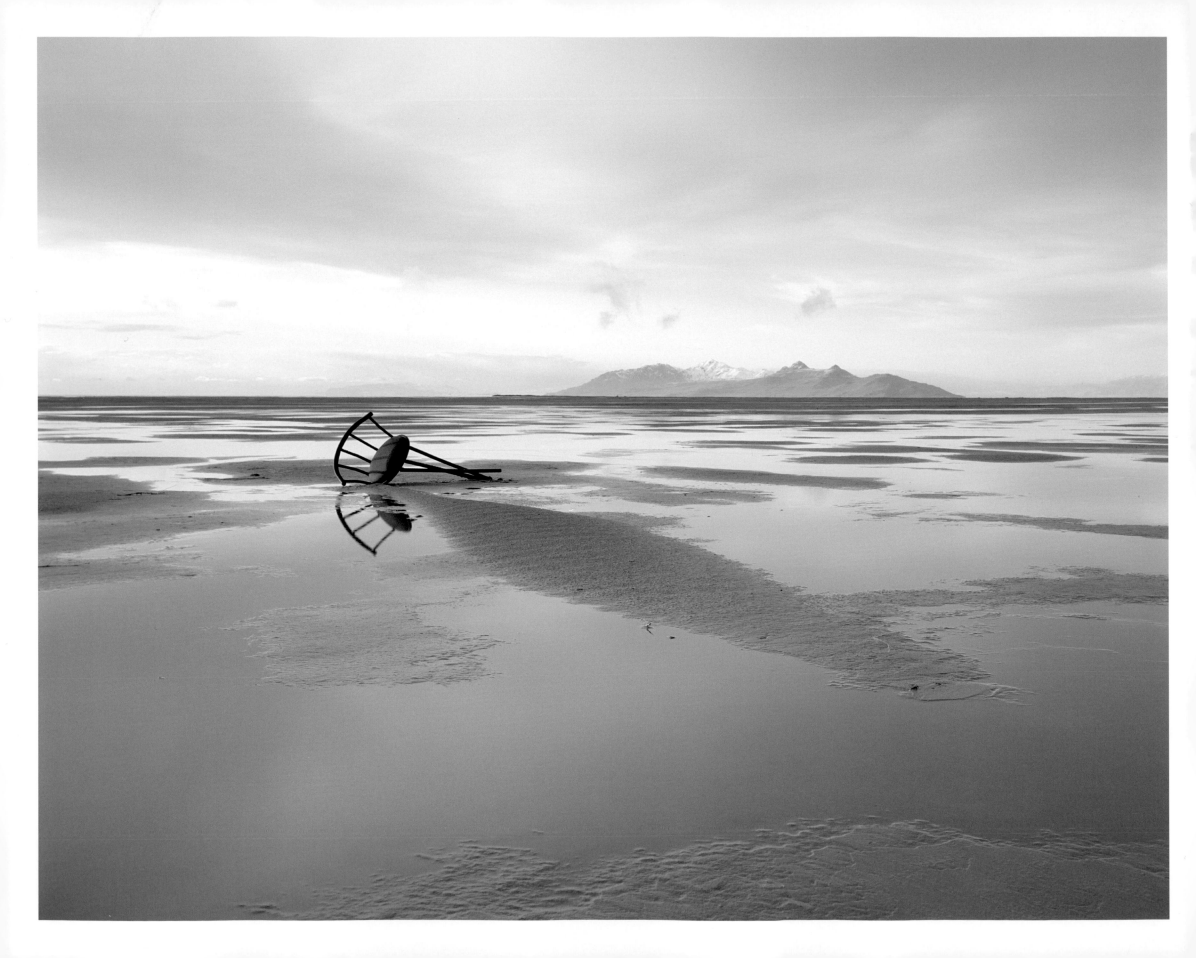

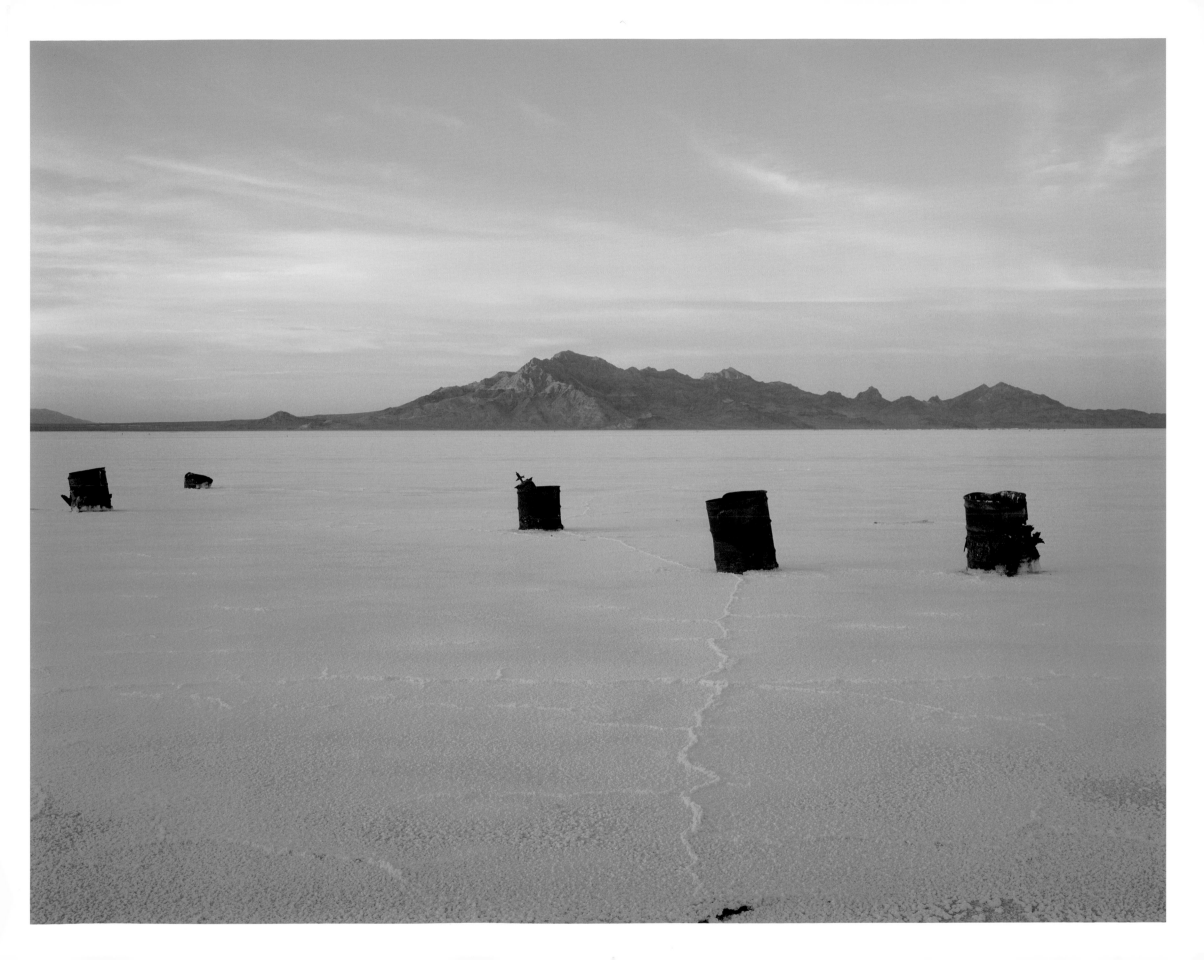

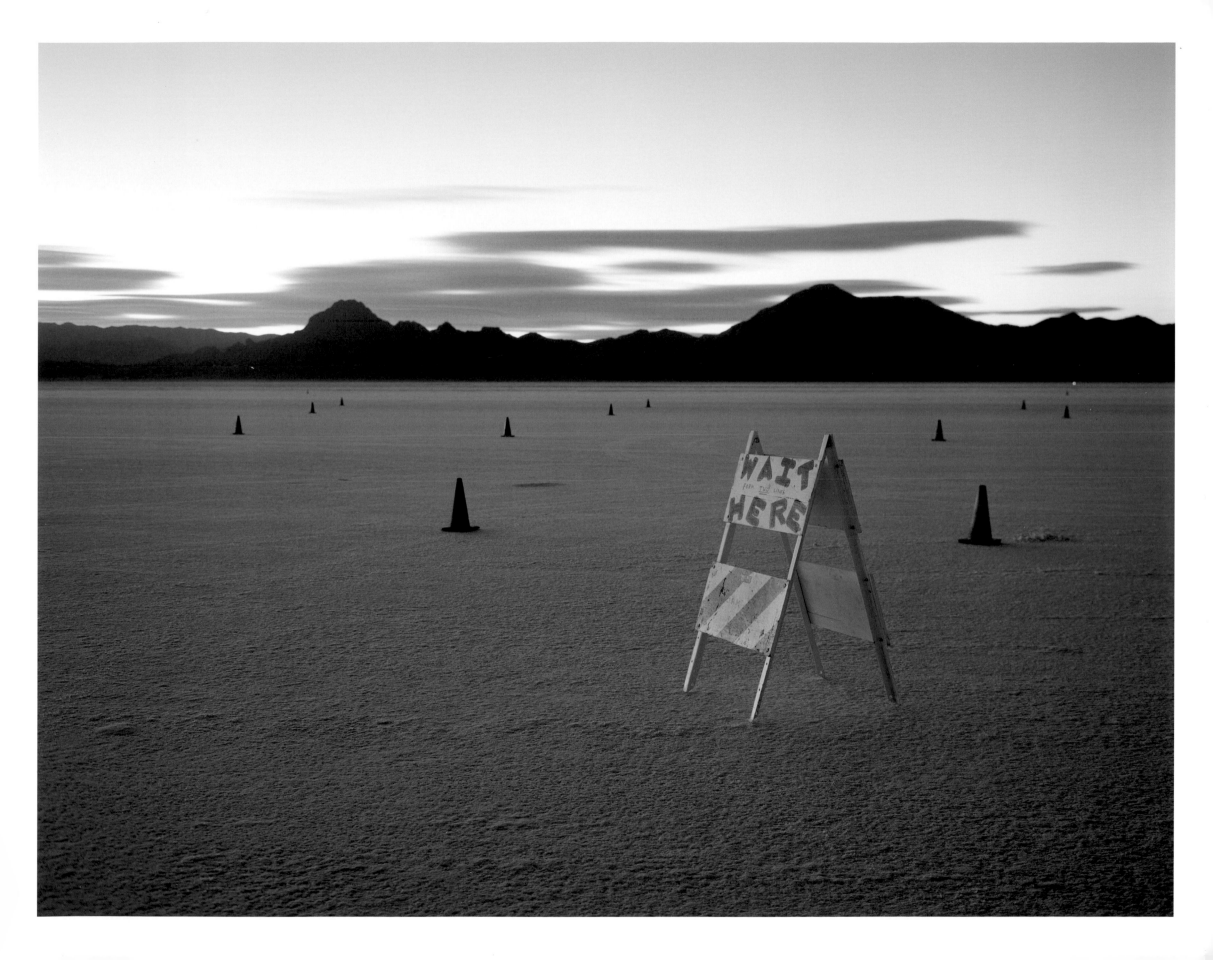

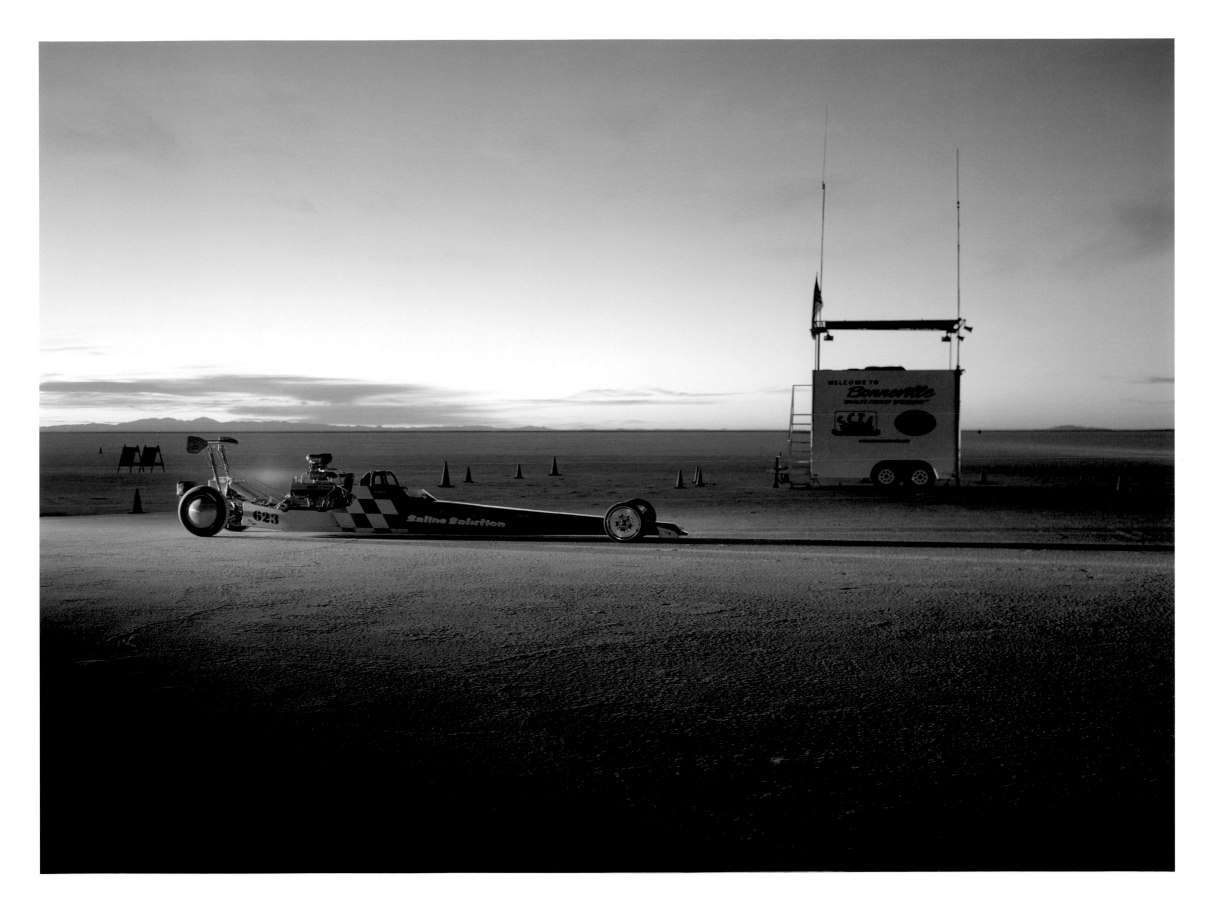

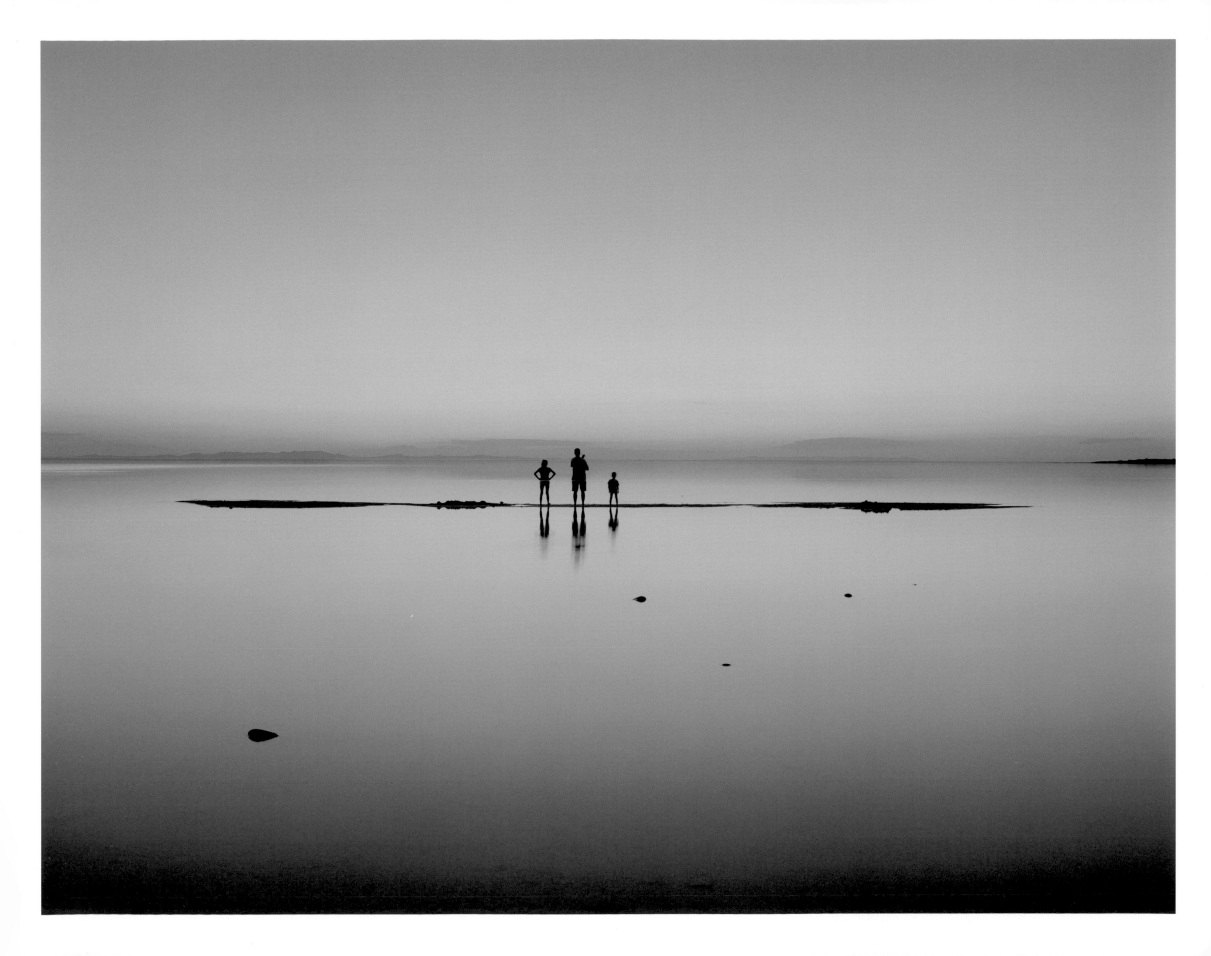

The Great Salt Lake, 2004–2005

All images made on film with a 4x5 camera

Lifting a Rocket

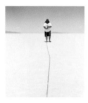

Rocket Launch

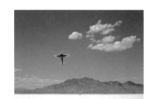

Yellow Plane

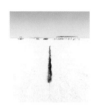

Winding a Spool

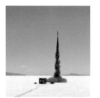

Short Black Line

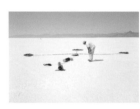

Examining a Rock

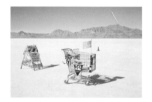

Shopping Cart and an American Flag

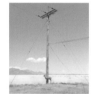

Deer Target

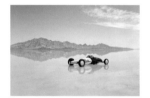

Lakester

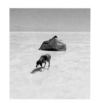

Dog on Salt

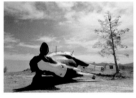

Cow

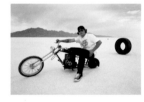

Young Man on a Chopper

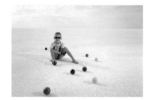

Boy with Boccie Balls

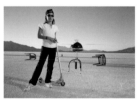

Girl with a Red Grill

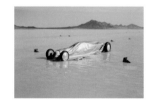

Silver Car

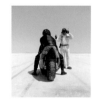

Man with an Umbrella on a Motorcycle

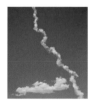

Rocket Trail

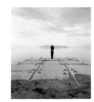

Cement Dock

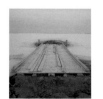

Salt Dock

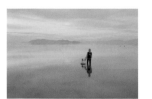

Girl with a Dog

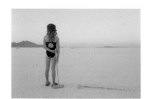

Girl with a Croquet Mallet

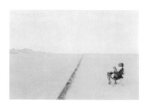

Man and a Black Line

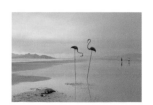

Flamingoes in the Great Salt Lake

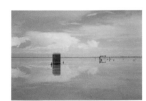

Toilet

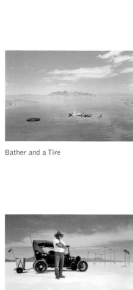

Bather and a Tire

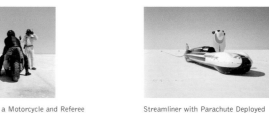

Streamliner Shell

Got Salt

Kicking a Ball

Superman

Rocket Nose and Parachute

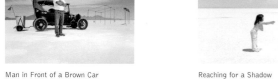

Man in Front of a Brown Car

Reaching for a Shadow

Smoking Car

Man on a Motorcycle and Referee

Streamliner with Parachute Deployed

Holding Rockets

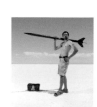

Shouldering a Rocket

Motorcycle in Motion

Man in a Maroon Car

Dog on a Chair and a Plane

Dragster at Dusk

Raised Car

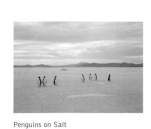

Penguins on Salt

Cross

Salt Berm

Playing Croquet at a Rocket Launch

World's Fastest Honda?

Long Black Line

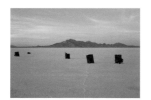

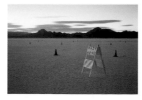

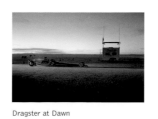

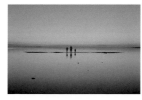

Bar Stool

Rusty Barrels

Wait Here

Dragster at Dawn

Island

Two Couches

ACKNOWLEDGEMENTS

Daniel Power for his belief in our work. Craig Cohen, Nicholas Weist, Kiki Bauer, Mine Suda, Amelie Solbrig, and Sara Rosen at powerHouse Books for their hard work and dedication to this project.

Vicki Goldberg and Francis Davis for their fine essays.

Emily Anhalt and George Petty for their enthusiasm, support, and generous consulting.

Laurie Liss, Francine Klagsbrun, Molly Haskell, Ruth Beesch, and Robert Cameron for their interest and assistance.

Anthony Accardi for his technical expertise.

Finally, for their love and support over the years, Eduardo Anhalt, Erica, Ariela, Fred Staff, Laurel Shepherd, Harri Uusitorppa, and Dan Miller.

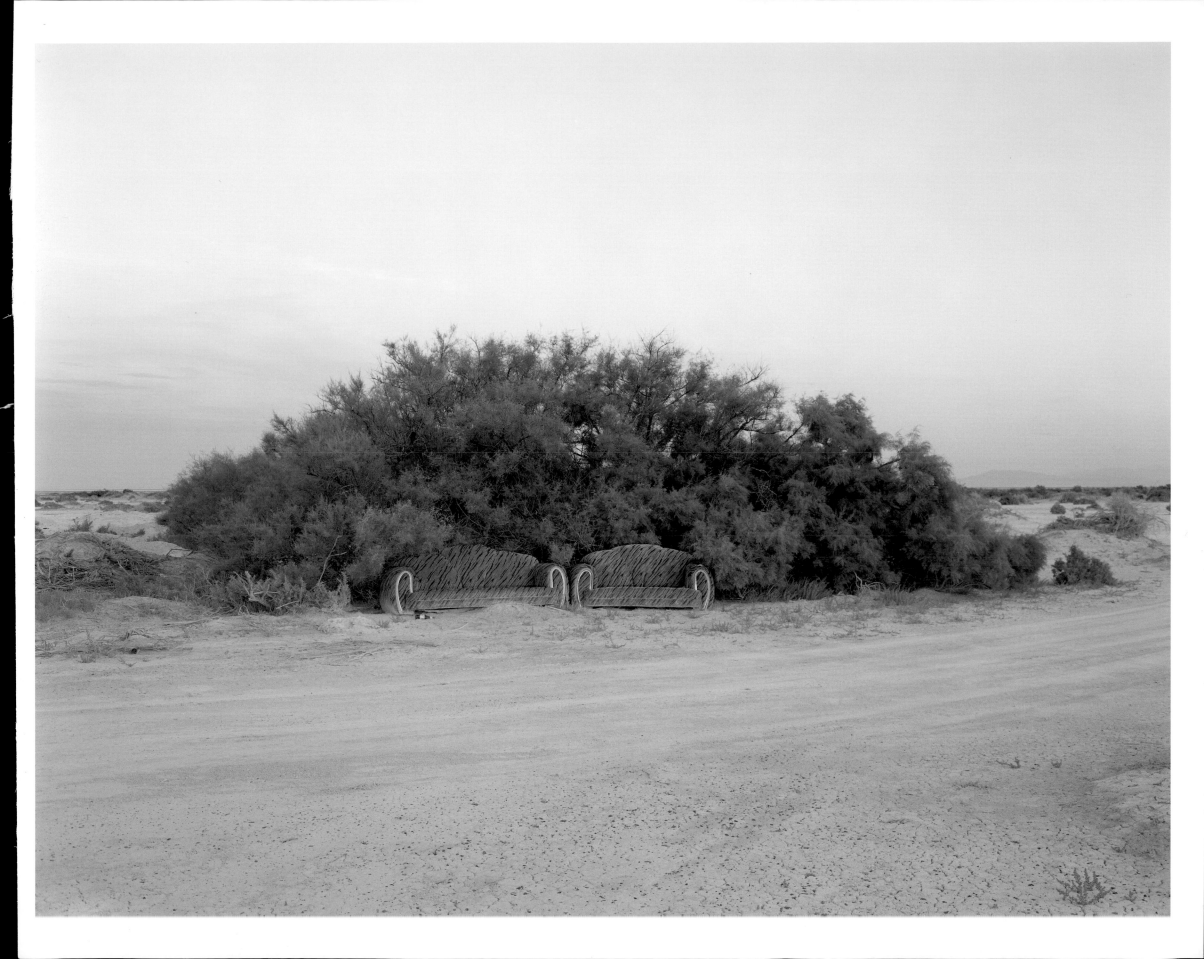

SALT DREAMS

Published in the United States by powerHouse Books,
a division of powerHouse Cultural Entertainment, Inc.
68 Charlton Street, New York, NY 10014-4601
telephone 212 604 9074, fax 212 366 5247
e-mail: saltdreams@powerHouseBooks.com
website: www.powerHouseBooks.com

First edition, 2005

Library of Congress Cataloging-in-Publication Data:

Katz, Jimmy.
 Salt dreams / by Jimmy and Dena Katz.
 p. cm.
 ISBN 1-57687-316-1
 1. Bonneville Salt Flats (Utah)--Pictorial works. 2. Utah--Description and travel. 3.
 Landscape photography--Utah--Bonneville Salt Flats. I. Katz, Dena. II. Title.

 F832.B6.K38 2006
 979.2'43--dc22

 2005056511

Hardcover ISBN 1-57687-316-1

Separations, printing, and binding by Oceanic Graphic Printing

Art direction by Kiki Bauer and Mine Suda
Designed by Amelie Solbrig

For more work by the Katzes, please visit www.jimmykatz.com.

A complete catalog of powerHouse Books and Limited Editions is available upon request;
please call, write, or race to our website.

10 9 8 7 6 5 4 3 2 1

Printed and bound in China